Y0-BDJ-157

Cameron Martin

analogue

Cameron Martin

analogue

With essays by:
MARTHA SCHWENDENER & ALEXANDER DUMBADZE

GHava{Press}
Brooklyn, New York

Notes on Landscape/Painting/ Photography/the Sublime

By MARTHA SCHWENDENER

Two stories about landscape: In the first, a young man is maneuvering through a remote canyon in Utah when a boulder shifts suddenly and pins his right hand. He spends the next few days chiseling away at the boulder until he realizes he is going to die if he doesn't get help soon. Using his body as leverage, he breaks the bones in his forearm. He cuts off his lower arm with a pocketknife and hikes back to civilization. In the second story, a group of men are skiing in the backcountry in California when one skis off a precipice. His companions make their way down to him. He is alive, but hurt. One of the men pulls out his cell phone to see if it works – and it does. They call for help and the man is rescued by helicopter.

• • • • •

William Henry Jackson went on seven expeditions with the Hayden geological survey. It was difficult, carrying photographic equipment into the wilderness and developing images there. But, "we were, so far as records show," Jackson writes about Mammoth Hot Springs, "the first white men ever to see those bubbling caldrons of nature, and I found myself excited by the knowledge that next day I was to photograph them for the first time."

• • • • •

The Hudson River School painters hiked mountains, climbed trees, and paddled rivers and streams. But the images they produced weren't made outdoors. Many of them were painted in the Tenth Street Studio Building in Lower Manhattan. By the 1860s, it was like a small landscape-painting factory. Artists like Frederic Church and Albert Bierstadt had studios there and at the height of their fame commanded $25,000 for a painting, allowing them to build mansions on the banks of the Hudson.

Edmund Burke published "A Philosophical Enquiry into the Origin of our Ideas of the Sublime and Beautiful" in 1757. "The passion caused by the great and sublime in nature," Burke wrote, "when those causes operate most powerfully, is Astonishment; and astonishment is that state of the soul, in which all its motions are suspended, with some degree of horror … no passion so effectively robs the mind of all its powers of acting and reasoning as fear." But Burke didn't necessarily think the sublime could be expressed in pictures. "It is in my power to raise a stronger emotion by the description than I could do by the best painting," he wrote. Nonetheless, artists were soon painting landscapes that evoked terror: a shipwreck in the Arctic; slaves being thrown into the sea; the Donner Pass in the High Sierras.

• • • • •

Jackson considered it a benefit to have a painter on the Hayden expedition. "Moran became greatly interested in photography, and it was my good fortune to have him at my side during all that season to help me solve many problems of composition." Jackson was aware of the limitations of photography. "So far as I am concerned," he wrote, "the great picture of the 1871 expedition was no photograph, but a painting by Moran of Yellowstone Falls, which hangs, or used to hang, in the Capitol in Washington. It captured, more than any other painting I know, the color and the atmosphere of spectacular nature."

• • • • •

Thomas Cole, the father of the Hudson River School, was born and spent the first seventeen years of his life in Lancashire, England, an industrialized district. In the last section of Cole's 1836 "Essay on American Scenery" he tells readers, "We are still in Eden; the wall that shuts us out of the garden is our own ignorance and folly." But Cole's folly isn't destroying the land; it's being blind to what's around us, not appreciating that "nature has spread for us a rich and delightful banquet." We should turn occasionally, he suggests, "from the ordinary pursuits of life to the pure enjoyment of rural nature; which is in the soul like a fountain of cool waters to the way-worn traveler."

Unlike Europe, the American landscape came with actual "savages." Jackson attempted to photograph them, but they resisted. In his diary, he wrote that one explained to him, "it make Indian heap sick, all die, pony die, papoose die." But if Native Americans had funny ideas about photography, so did Europeans. Nadar writes that Balzac had a theory that "all physical bodies are made up entirely of layers of ghostlike images, an infinite number of leaflike skins laid one on top of the other … he concluded that every time someone had his photograph taken, one of the spectral layers was removed from the body and transferred to the photograph."

• • • • •

Thomas Cole's five-painting cycle "The Course of Empire," conceived while in Rome using a studio purportedly occupied by the great 17th century ideal landscape painter Claude Lorrain, was also filled with terror. The civilization that rises and falls in Cole's cycle looks a lot like Rome, but the artist was coming to feel that America was heading into dark territory. The last canvases show invaders sweeping through a decadent empire.

• • • • •

One of the most famous 19th century American landscapes, painted by Cole's only pupil, Church, was the composite "Heart of the Andes" from 1859. The painting used different elements seen by Church on a trip financed by a businessman with concerns in South America (hoping to use Church's paintings as marketing tools) cobbled together in one composition and later displayed in the Tenth Street Studio Building, in a carefully lit and staged room.

• • • • •

The greatest American artwork of the 19th century: Central Park. The first landscaped public park in the United States, Frederick Law Olmstead and Calvert Vaux's Greensward Plan was influenced by the landscape paintings of Claude and the Claude-influenced British parklands of Lancelot "Capability" Brown. The Greensward plan included different zones described by categories like "pastoral" or "pic-

turesque sylvan." In 1853 the state legislature of New York authorized the City to use the power of eminent domain to acquire over 700 acres of land in the center of Manhattan, terrain with swamps and bluffs and rocky outcroppings, displacing 1,600 residents – mostly Irish pig farmers, German immigrants, and African-Americans.

• • • • •

The left side of Cole's "View from Mount Holyoke, Northampton, Massachusetts, after a Thunderstorm – The Oxbow" depicts a tangled, untamed wilderness; the right side, a landscape marked by flattened fields. Some have described the painting as divided between the Romantic sublime and the Claudian beautiful. Cole was ambivalent about expansion and development. "I cannot but express my sorrow that the beauty of such landscapes are quickly passing away," he wrote. "The ravages of the axe are daily increasing – the most noble scenes are made desolate, and oftentimes with a wantonness and barbarism scarcely credible in a civilized nation." But progress is progress: "Such is the road society has to travel."

• • • • •

When Bierstadt traveled West with the Lander's Survey in 1859, he made sketches and took stereoscopic photographs of Native Americans and immigrants, which he gave to his brothers to start a photography business in New York. Returning east, he painted "The Rocky Mountains, Lander's Peak," the first of his monumental Western landscapes. He exhibited it at the 1864 Metropolitan Fair in New York with a tableau vivant of Native Americans. When he returned to California in 1871, the transcontinental railroad had flooded the valley with tourists, so he went elsewhere, to areas still pristine.

• • • • •

Burke's notion of the sublime included two other concepts: vastness and obscurity. "The ocean is an object of no small terror," he wrote, supporting the first one. "To make any thing very terrible, obscurity seems in general to be necessary. When we know the full extent of any danger, when we can accustom our eyes to it, a great deal of the apprehension vanishes." The dark is a good example. But Burke also

mentions politics. "Those despotic governments, which are founded on the passions of men, and principally upon the passion of fear, keep their chief as much as may be from the public eye."

• • • • •

Twenty-thousand workers were employed in the building of Central Park. Rocky ridges had to be blasted; three million cubic yards of soil were moved; more than 270,000 trees and shrubs were planted. The existing rectangular reservoir was re-shaped into a more "natural" curving form. In conceiving their plan, Omstead and Vaux drew from experience – Omstead as a gentleman farmer in Connecticut and Staten Island; Vaux designing picturesque "rural" house plans up the Hudson. They were also fed by the ideas of Ralph Waldo Emerson, and John Ruskin, who never visited America because, "I could not, even for a couple of months, live in a country so miserable as to possess no castles."

• • • • •

Writing about Poussin in 1821, William Hazlitt, himself a failed painter, argued for the primacy of landscape, reversing the old academic hierarchy which privileged history painting. Hazlitt had his own way of reading Poussin, however: he ignored the figures populating the paintings and focused instead on the scenery – just as 20th century artists would rephotograph advertising images of cowboys galloping through the Great American West, leaving out the captions.

• • • • •

Robert Smithson called the Greensward Plan for Central Park an "earth sculpture" and Olmstead "America's first 'earthwork artist.'" After all, Smithson wrote, "Olmstead made ponds, he didn't just conceptualize about them." Olmstead's creation in New York was "recycled," but Smithson still considered something like Yosemite "wilderness" because it wasn't made by human hands – although "today, Yosemite is more like an urbanized wilderness with its electrical outlets for campers, and its clothes lines hung between the pines." Smithson thought of the Western desert as "less 'nature' than a concept, a place that swallows up boundaries." Olmstead, for his part, hated California and called the desert "detestable."

With landscape, it's often a question of addition or subtraction: what to take out, what to leave in. Lorrain's landscapes, like those of Church – or early photographers like Gustave Le Gray – were composites, made from different views, sources, or negatives. But then, as Jeremy Gilbert-Rolfe writes, "all of Western painting erases as it adds. What's underneath can be quite unlike what's on top, unlike in, say, Chinese painting … You can x-ray a Western painting and find something no one knew was there."

• • • • •

When Smithson wrote about Central Park in 1973, he remarked that "The Ramble has grown up into an urban jungle, and lurking in its thickets are 'hoods, hobos, hustlers, homosexuals' and other estranged creatures of the city." The picturesque-pastoral landscape had been invaded, "a clump of bushes can also be a mugger's hideout." Walking through the park, he saw graffiti on boulders, "aggressive" squirrels, wild dogs, a brook "choked with mud and tin cans," a pond "aswirl with oil slicks, sludge, and dixie cups." He suggested dredging out the mud, treating it "in terms of art, as a 'mud extraction sculpture.'"

• • • • •

Like Cole, Asher Durand wasn't a conservationist; he made paintings like "Advance of Civilization" that supported "progress" and expansion. In 2005, the New York Public Library held an auction to sell Durand's "Kindred Spirits," which depicts a recently-deceased Cole and poet William Cullen Bryant conversing in the Catskills – a painting long connected with ideas of American wilderness and cultural identity. The painting was bought by Walmart heiress Alice Walton for $35 million, prompting an outcry: neo- expansionists had seized America's patrimony. Now the destiny of art objects themselves was at stake.

• • • • •

A contemporary artist has photographed "The Oxbow," but from the vantage of a flat field below Mount Holyoke. The pictures are described as a "systematic index," a document of weather and the seasons – which might be altered soon by climate

change. Similarly, another artist has made a sculpture called "The Dinner Party," a ring of covered wagons with thrift-shop detritus perched on top. Here, art history and American history have been collapsed into a puerile joke.

•••••

Two more stories about landscape: In the first, a young man gorged with Thoreau and Jack London treks into the Alaskan wilderness with little more than a .22 caliber rifle and a 10-pound bag of rice. After 112 days alone in the wilderness he starves to death. His 67-pound body is found, along with a diary, in an abandoned bus. His story is made into a best-selling non-fiction book, then a movie. In the second story, two young men go for a walk in the New Mexico desert and get lost. One of the men, according to the survivor, begs his friend to kill him, which the friend does. This one is also made into a movie, which reviewers compare to Beckett's "Waiting for Godot."

•••••

The sublime has undergone a number of changes since Burke. For Kant, it existed in reception rather than production, spurred only by natural objects. (Pictures of natural phenomena could only be beautiful; "Night is sublime, day is beautiful.") Hegel located it in "the Idea … struggling and striving after" a form. Adorno felt it "might be better to stop talking about the sublime completely," because "the term has been corrupted beyond recognition by the mumbo jumbo of the high priests of art religion." Derrida diagnosed boundary issues: the sublime was the limitless or unbordered. Lyotard saw it as the modernist attempt to present the unpresentable, the "negative presentations" of Malevich, Klee, and Barnet Newman – whose own essay, "The Sublime is Now," stated that the "impulse of modern art" was a desire to "destroy beauty."

•••••

When Ed Ruscha's "Course of Empire," a cycle of ten paintings with flat images of the post-industrial landscape – five in black and white, like old photographs – were shown at the Whitney Museum, after representing the United Sates at the 51st

Venice Biennale, they were accompanied by a room hung with lightboxes housing reproductions of Cole's paintings from the 1830s. The obvious thing would have been to borrow the real Cole paintings from the New York Historical Society and transport them a few blocks across Central Park. But Cole's paintings took on a new look, and perhaps a new meaning: as illuminated photographs.

•••••

In 2005, 5,000 tons of steel and 1,067,330 square feet of saffron-colored nylon fabric were made into 7,500 gates erected along 23 miles of footpaths for an independently funded (and later disputed) $20 million. Land art had been brought to Central Park by Europeans who claimed Olmstead and Vaux as inspirations, and who had previously engaged in more critical acts of public art like "Iron Curtain, Wall of Oil Barrels" and "Wrapped Reichstag." The project was originally conceived in the 1970s; now Central Park was cleaner and brighter - outfitted for an age of tourism and a work the artists hoped would create "joy and beauty."

•••••

In contemporary disaster-landscape stories, culture is framed as emasculating; nature – remote or semi-remote wilderness – offers a promise of return. But just like 19th century disaster-landscape stories, these echo history. The Donner Party was comprised of Western settlers. Now "wilderness" is associated with leisure: hiking, mountain climbing, camping, skiing. The quest for property has given way to the quest for adventure.

•••••

Beauty has become embarrassing to speak of in art, but terror has gone the way of the avant-garde, becoming an "ism." Karlheinz Stockhausen compared 9/11 to a concert, with the hijackers "concentrated on this single performance." For him, it was "the greatest work of art there has ever been." Some argued that Stockhausen was thinking in terms of the Burkean sublime: he wasn't in danger, so he derived aesthetic pleasure from the experience.

Landscape might be called something else now: the environment, for instance. The environment hides things: radiation, contaminated groundwater. Natural gas pipelines from the Gulf of Mexico cross under the Hudson, virtually invisible. A defense control center is hidden in a mountain in Colorado. The Internet was about making power disappear into the landscape, decentralizing it. "The term 'cyberspace,'" Jeremy Gilbert-Rolfe writes, "seems fatuous because it is precisely space that has been eliminated, cyber or any other." By comparison, in Gainsborough's 18th century landscape paintings, power was right there in the picture: oak trees signified ship masts and Britain's naval-colonial supremacy; hardworking Protestants in the foreground were supporters of enlightened land management.

• • • • •

Prospect Park in Brooklyn was also designed by Olmstead and Vaux, and constructed at the same moment landscape painters were working on Tenth Street in Manhattan and photographers were traveling with the Western geological surveys. It, too, is like walking through a Claude painting. Or at night: Tony Smith's famous description of his nocturnal car ride on the uncompleted New Jersey Turnpike: "It was a dark night and there were no lights or shoulder markers, lines, railings, or anything at all except the dark pavement moving through the landscape of the flats, rimmed by hills in the distance, but punctuated by stacks, towers, fumes and colored lights … The road and much of the landscape was artificial, and yet it couldn't be called a work of art … artificial landscape without cultural precedent began to dawn on me."

• • • • •

Claude was one of the best landscape draughtsmen in history, and he drew from nature. Pierre-Henri de Valenciennes, one of the first academy-approved landscape painters, advocated copying from nature rather than other paintings. Later the conversation switched from painting-from-nature to painting-from-photography. Ingres, Delacroix, Degas, Edouard Vuillard, Pierre Bonnard, Gustave Caillebotte, and Thomas Eakins all painted from photographic sketches, although they often hid it.

David Hockney argues that painting was virtually always done from some (proto) photo-technology: the camera obscura or the camera lucida. Recent years have brought the "good," European conceptual painting-after-photography (Gerhard Richter) and the "bad" American Photorealism.

•••••

In his essay "Art and Objecthood," Michael Fried attacked Smith's description of his ride on the unfinished New Jersey Turnpike as something replicating "theatricality," similar to what Minimalist (what Fried calls "literalist") art did to the viewer. High modern art, by comparison, wasn't "perverted by theater." One wonders what Fried would have thought of Church's "The Heart of the Andes" displayed in the New York Studio Building, where it was suggested that viewers use opera glasses to see the details better.

•••••

The question of what it means to make a painting after photography has been answered a number of ways. Painting is dead. Painting will outlive photography. What is painting? What is photography? Peter Osborne wrote that Gerhard Richter's "return to the source of the crisis (the displacement of painting from its naturalistic representational function)" in his photo-paintings is essentially an "affirmation of photography by painting." Richter's paintings are "negatives of paintings, negatives of photographs." On the other hand, Gilbert-Rolfe is more practical: the answer is not that there's "no need for painting after photography, but that there's no need for drawing."

•••••

And what about the photographs of Jackson, Watkins, Muybridge, O'Sullivan and others: should they be considered alongside Cole, Durand, Bierstadt, and Church? "Everywhere at present there is an attempt to dismantle the photographic archive – the set of practices, institutions, and relationships to which 19th century photography originally belonged," Rosalind Krauss wrote in the early 1980s, "and to reassemble it within the categories previously constituted by art and its history."

To Siegfried Krakauer, writing in the 1920s, "The photographic archive assembles in effigy the last remnants of a nature alienated from meaning. This warehousing of nature promotes the confrontation of consciousness with nature. Just as consciousness finds itself confronting the unabashedly displayed mechanics of industrial society, it also faces, thanks to photographic technology, the reflection of the reality that has slipped away from it." Allan Sekula put it even more succinctly: "photography is haunted by two chattering ghosts: that of bourgeois science and that of bourgeois art."

• • • • •

Contemporary imagination and the landscape: This might involve going online to Expedia or Travelocity and looking for a Last Minute Deal, a trip to somewhere exotic – perhaps in the Southwest. But the homogeneity of the landscape is obvious, even in the thumbnail photos: the Econo Lodge in Albuquerque looks the same as one on the outskirts of Phoenix. Artists like Robert Adams and Ed Ruscha recorded the banality of the Western landscape in photographs. When asked in the 1970s, "do you have any hope for the American landscape?" Adams replied, "I'm not worried about the landscape. What worries me are the people who care so little for it."

• • • • •

For Richter, the relationship between painting and photography could be posed as an absurd-surreal joke. In 1966 he suggested that "all painters, in fact everybody, should paint copies of photos – that is, in the manner in which I do … then such paintings should be exhibited and hung everywhere: in apartments, in restaurants, in offices, in railway stations, in churches, everywhere. Subsequently a prize competition would be held, and the jurors would judge on the basis of chosen theme, depiction, and speed of the copying, and then award medals. Television and radio would report every day on the latest pictures. After a while, laws would be enacted that would lead to punishment of anyone who had not painted copies of a sufficient number of photographs. This process would have to last for approximately 400 years, after which painting photographs would be forbidden in Germany."

The "ism" gave way to "post": postindustrial, postmodern, post-feminist, post-9/11, post-studio, post-theory. Are we post-landscape and post-photography yet? Perhaps landscape has dissolved into the environment and photography into the digital realm. What would a post-landscape image look like? Would it exude what Gilbert-Rolfe describes as the "post-human techno-sublime"? Landscape is no longer merely an aesthetic term. Rebecca Solnit conceives it as "the spaces and systems we inhabit, a system our own lives depend on … the microcosmic as well as the macrocosmic, economies as well as ecologies, the cultural as an extension of the natural, our bodies as themselves natural systems that pattern our thoughts, and our thoughts as structured around metaphors drawn from nature."

•••••

The young man who cut his arm off has a website, of course. He wrote a bestselling book titled "Between a Rock and a Hard Place". He's been paid to do motivational speaking, to share his "inspirational survival story," and to be a spokesman for a beer company. In his book, he admits he was foolish to ignore the basic mountaineering precept: tell someone where you're going when heading into the wilderness. Or perhaps he didn't think the United States contained a place that remote anymore.

19

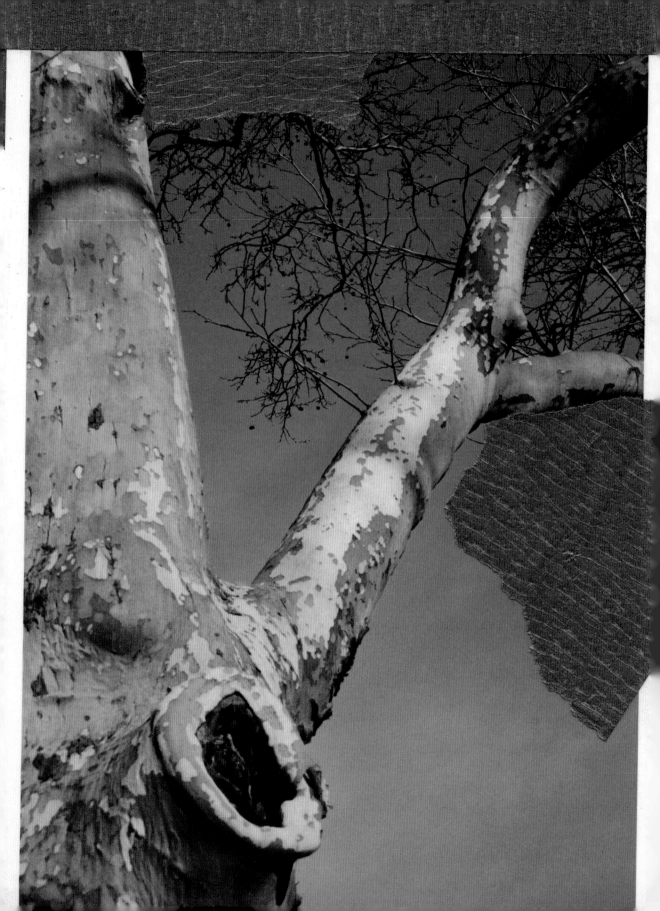

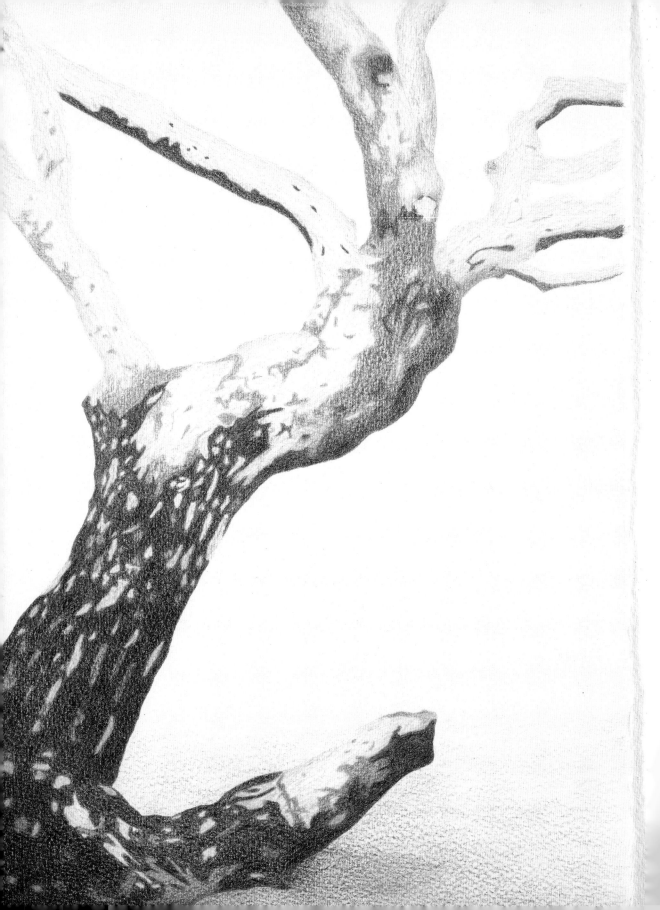

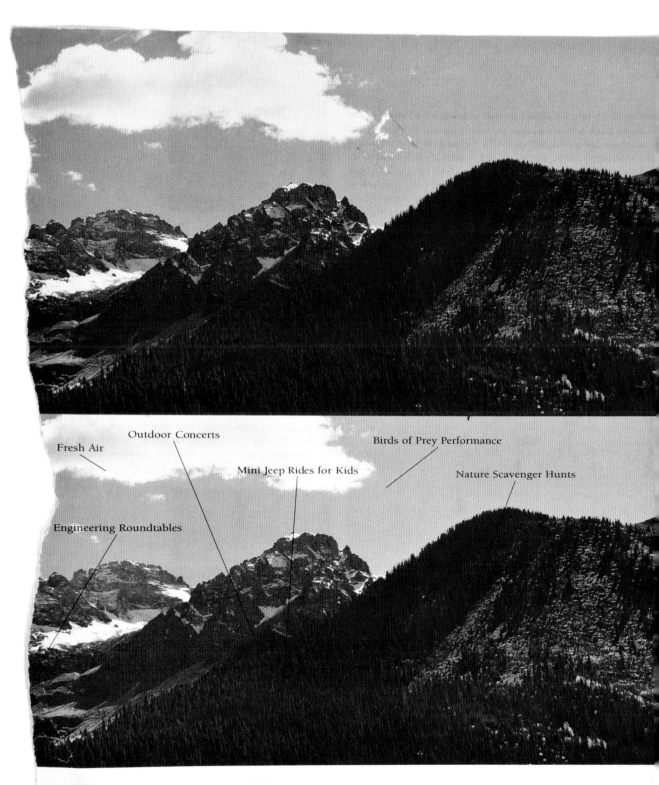

Fresh Air

Outdoor Concerts

Birds of Prey Performance

Mini Jeep Rides for Kids

Nature Scavenger Hunts

Engineering Roundtables

And, once you're ready, you're free to take on any of our scenic 4x4 trails yourself. There's no limit to the fun you can have. You can talk to Jeep engineers. Learn archery. Or take a hike. And with many activities geared to kids, like leaf etching and sand painting, Camp Jeep is a great idea for a family vacation.

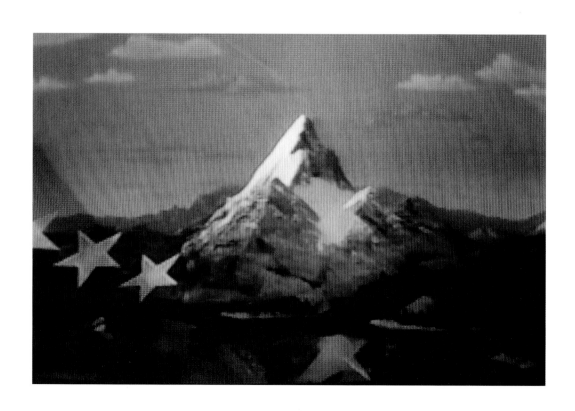

HAVE ALWAYS FORCED OTHER CARS TO BE SAFER.

THIS ONE WILL FORCE THEM TO BE BETTER.

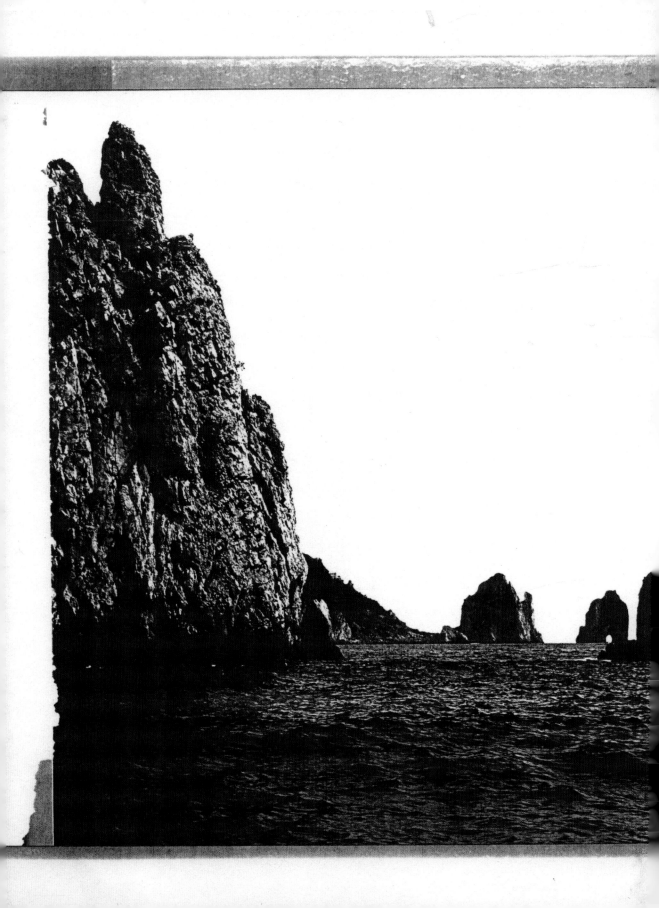

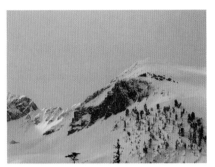

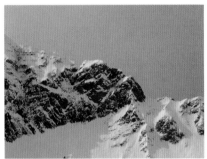

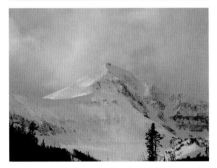

WE MUST

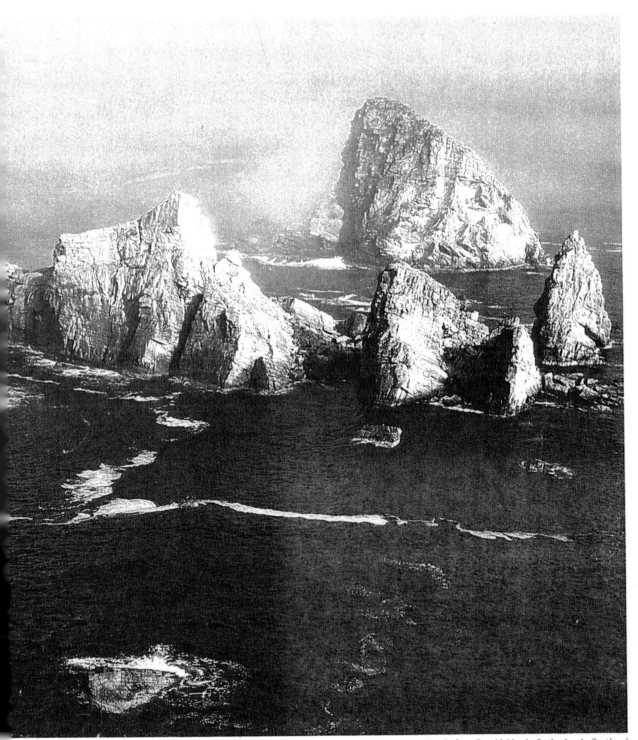

North Sea, Faraid Head, Sutherland, Scotland

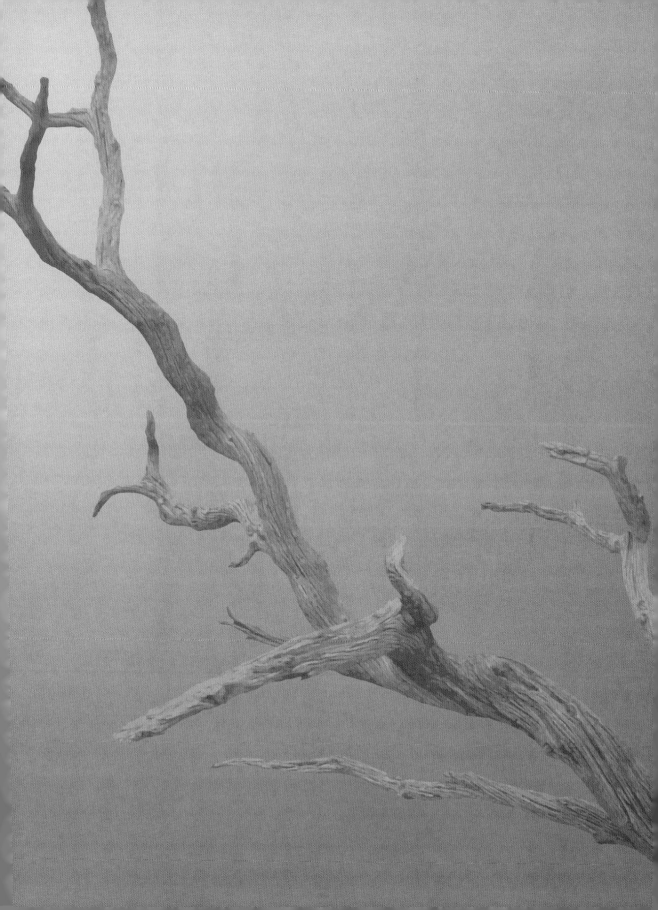

1 2 3 4 5 6 7/8

9 10 11 12 black

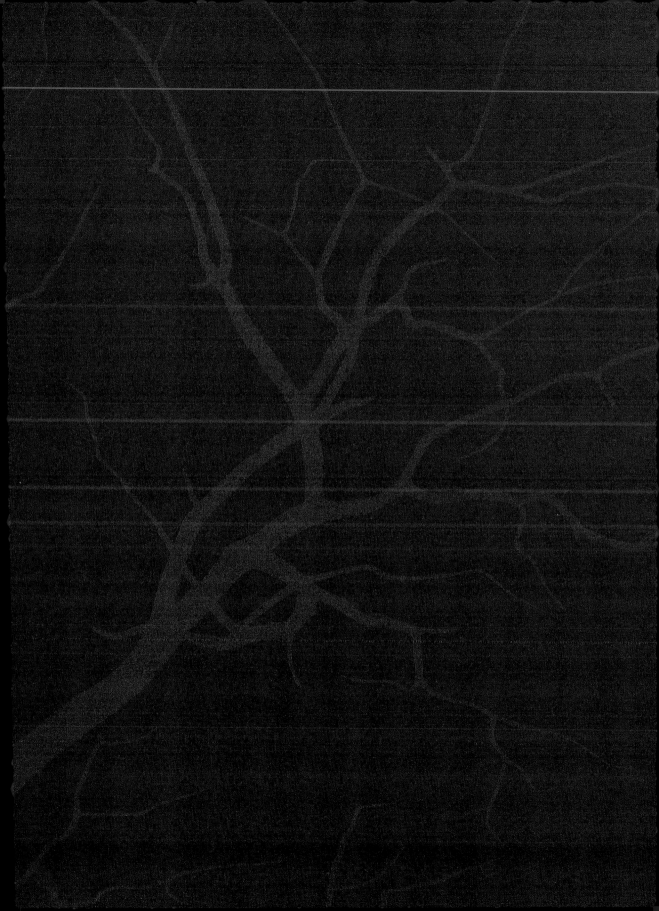

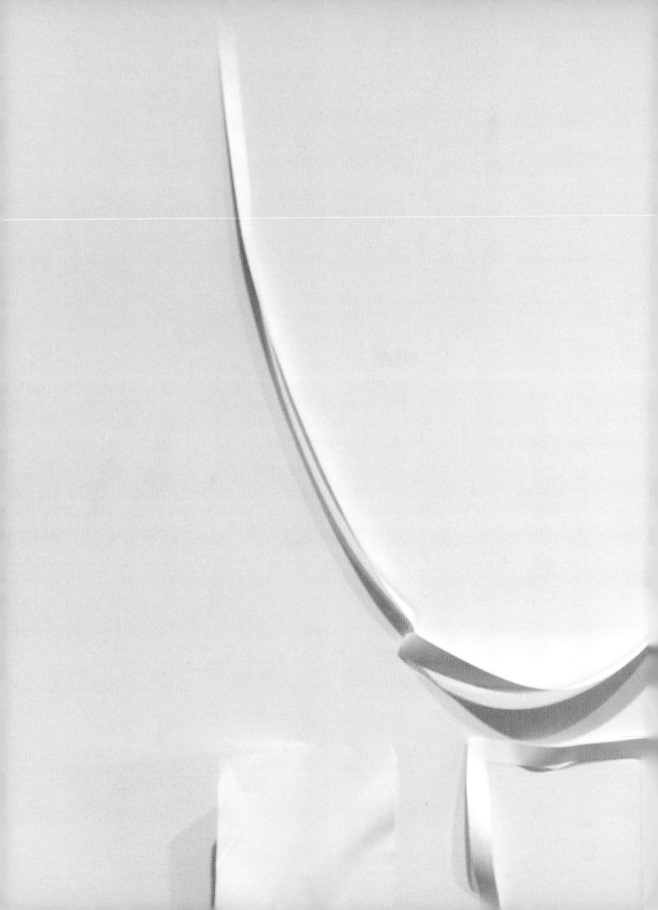

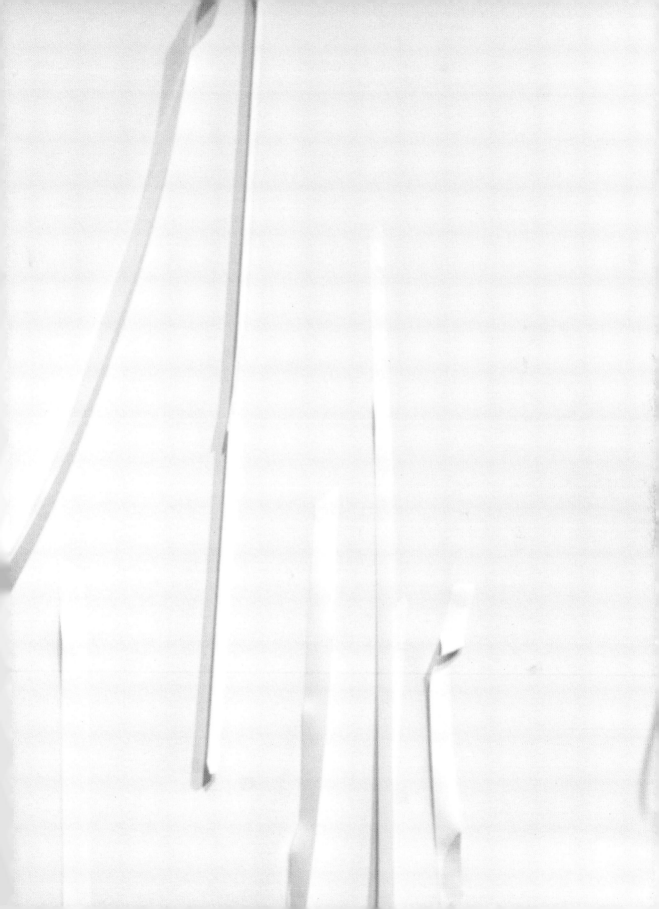

#20,562 (1987)

EXPLORERS, TRAVELERS & ADVENTURERS
EST. 1967

REG. U.S. PAT. OFF.

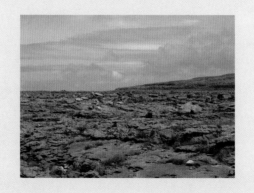

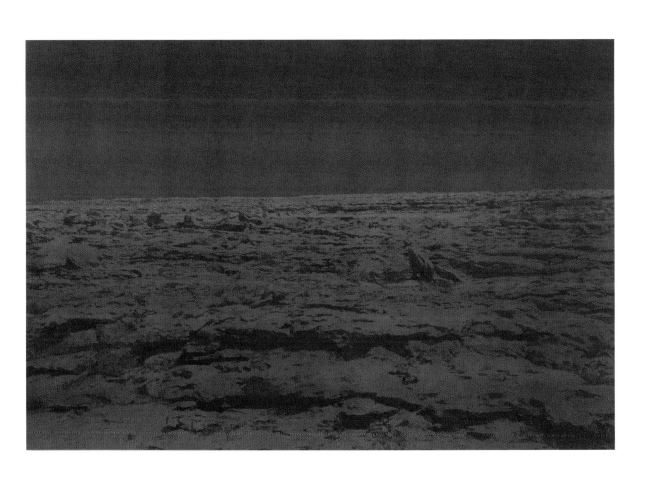

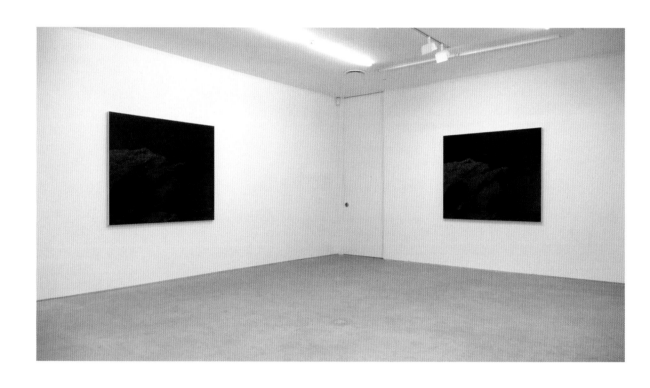

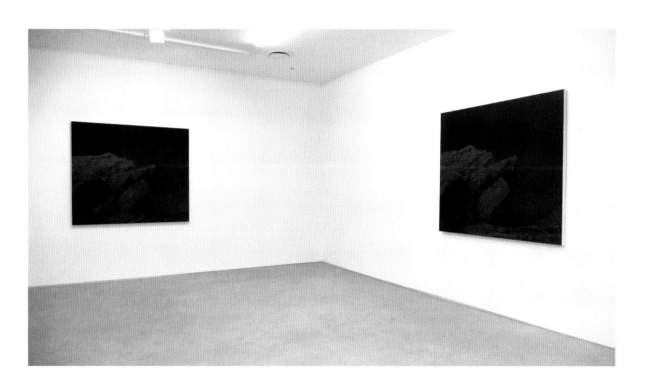

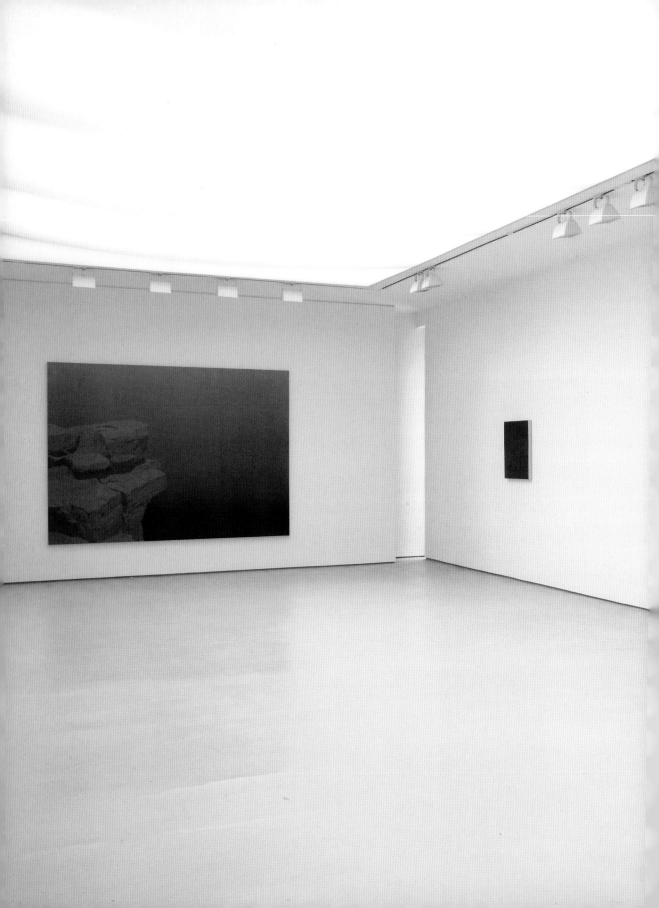

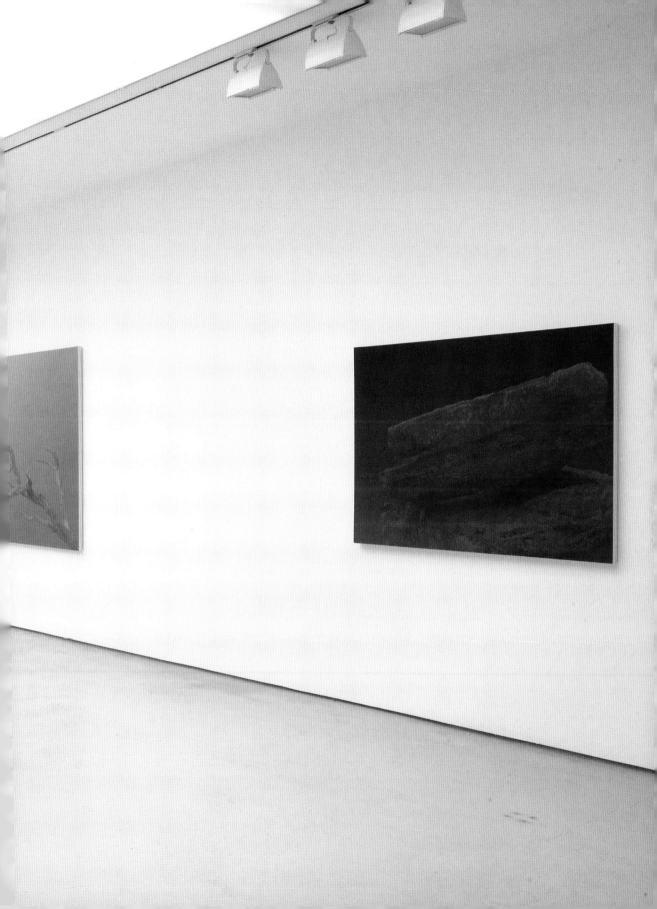

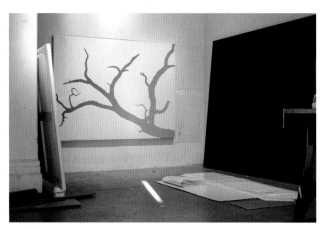

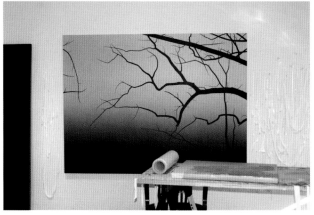

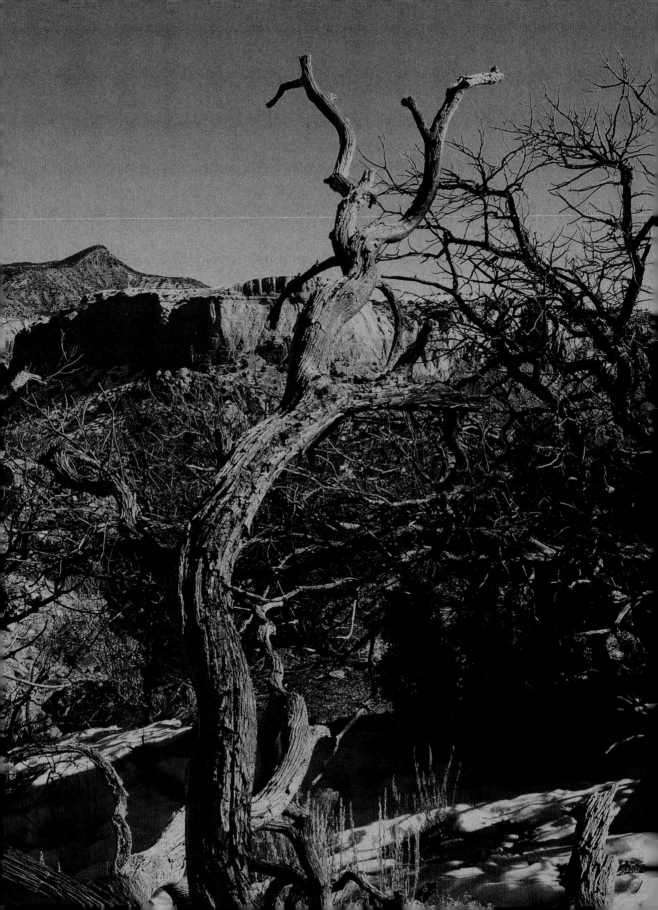

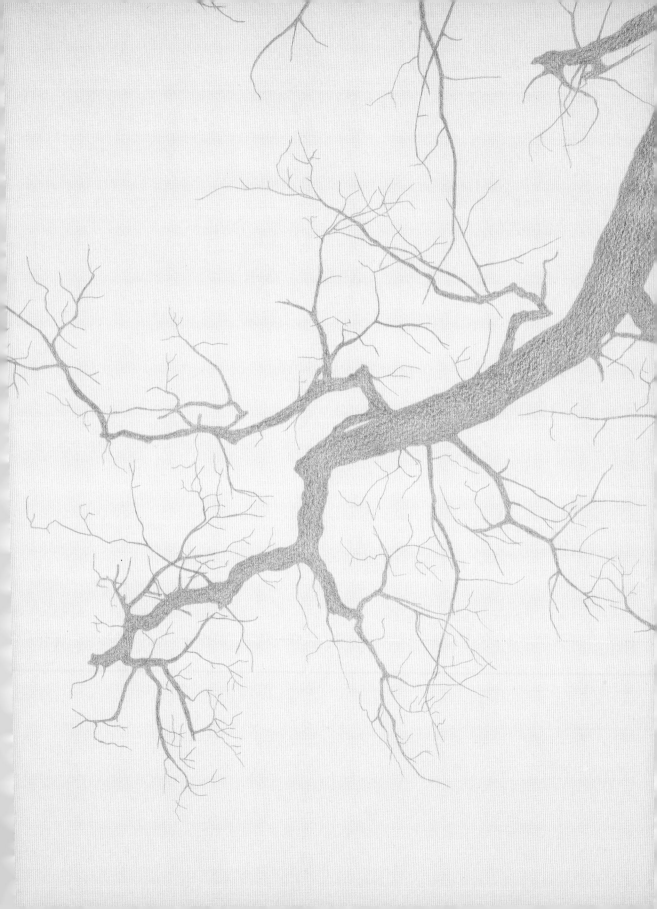

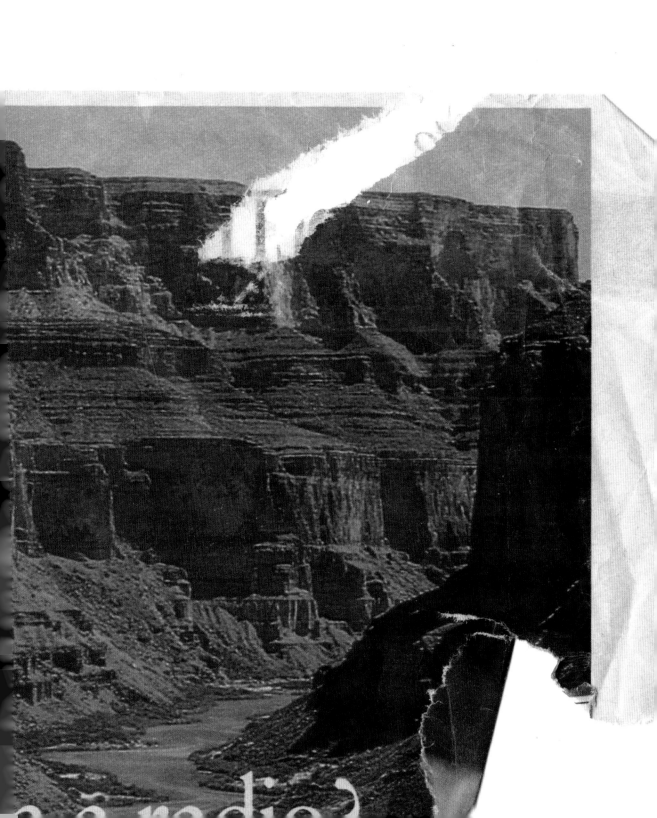

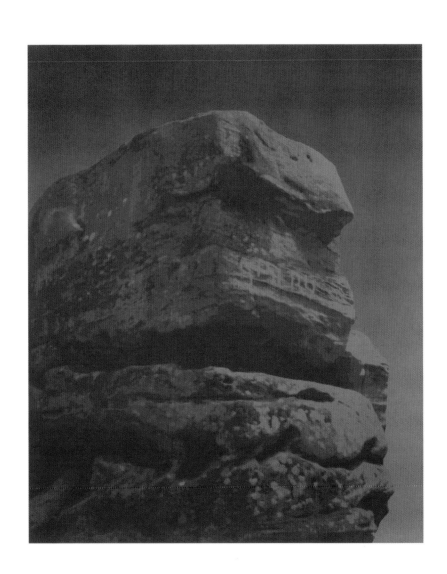

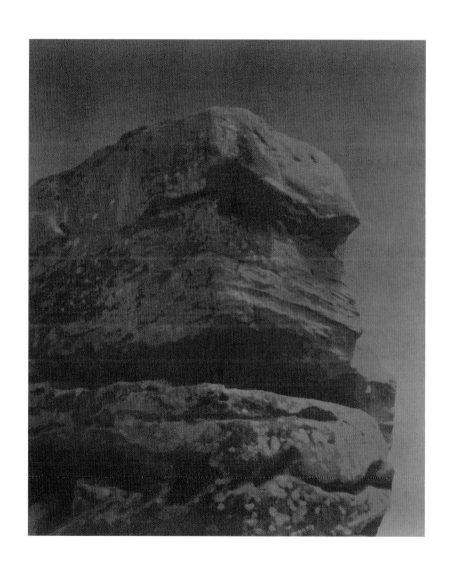

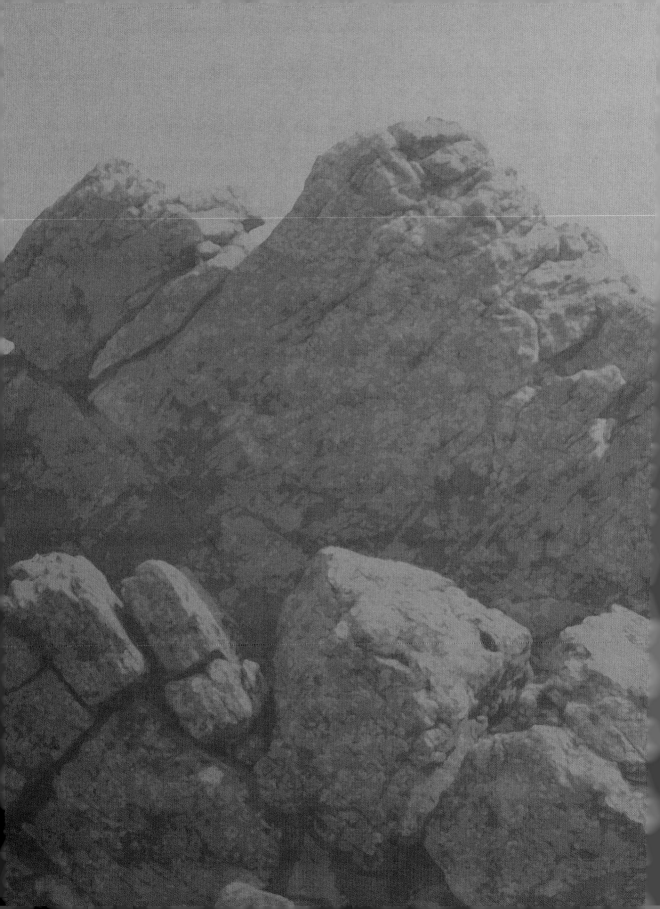

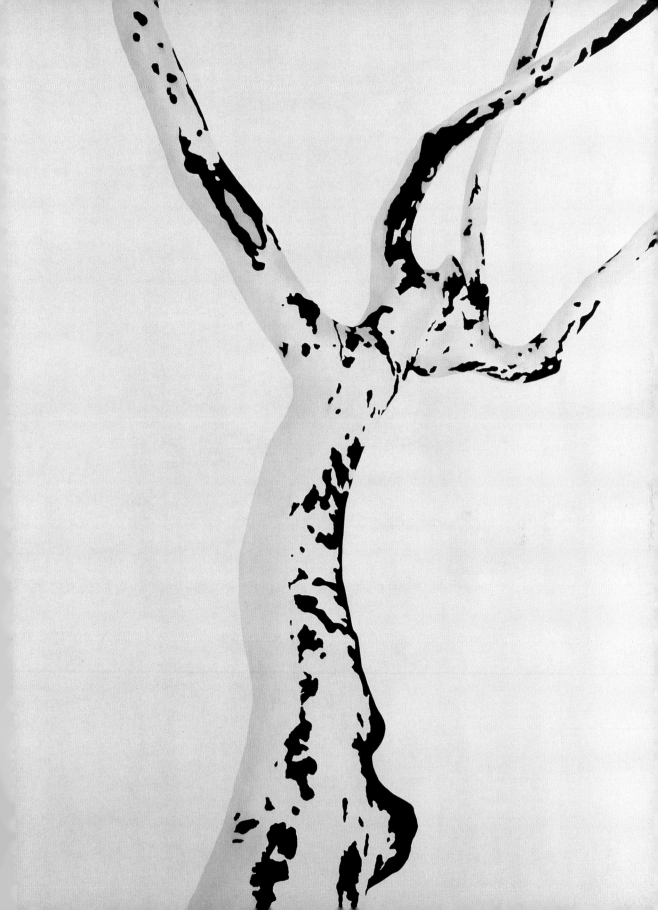

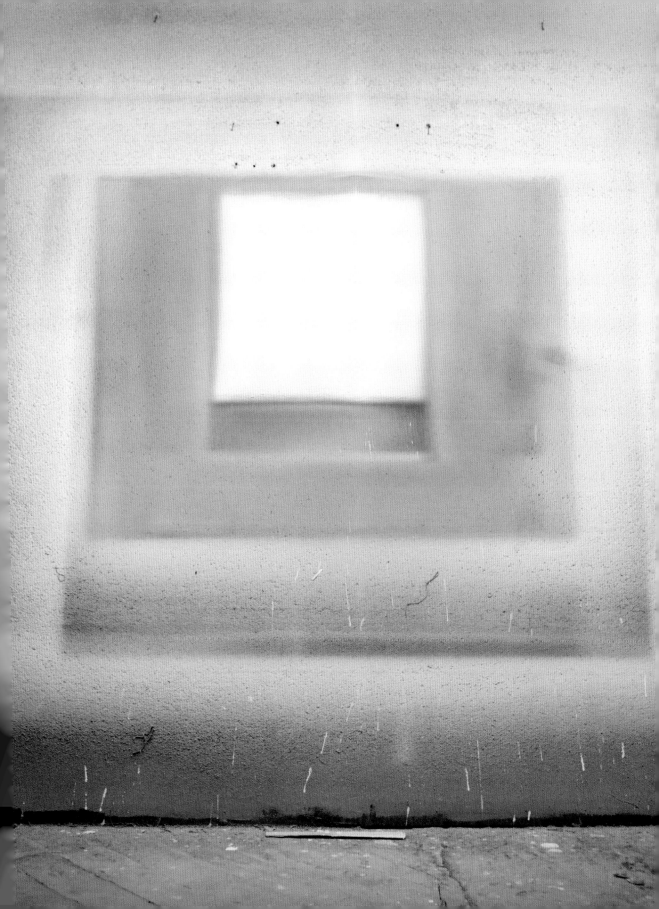

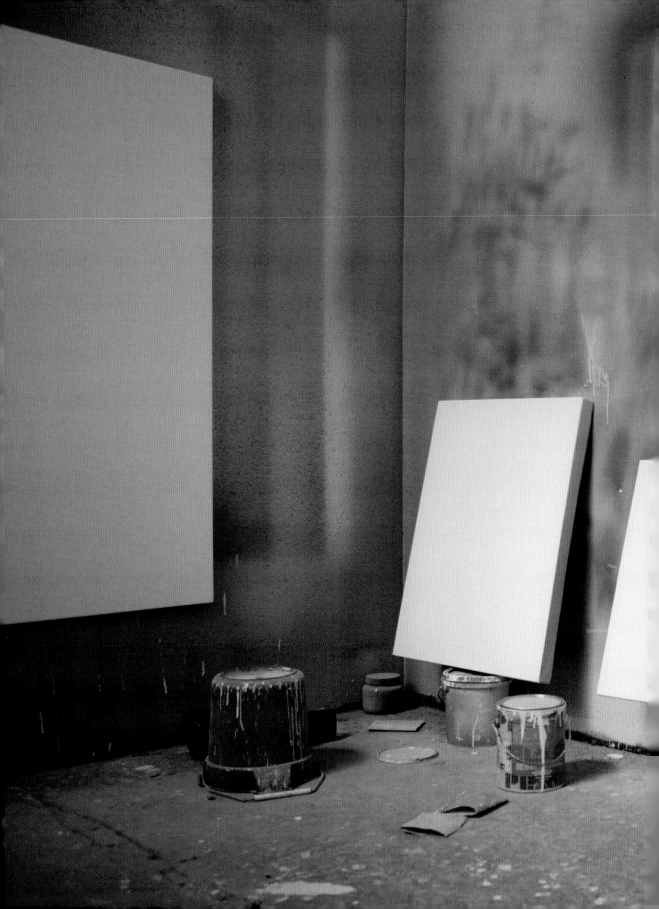

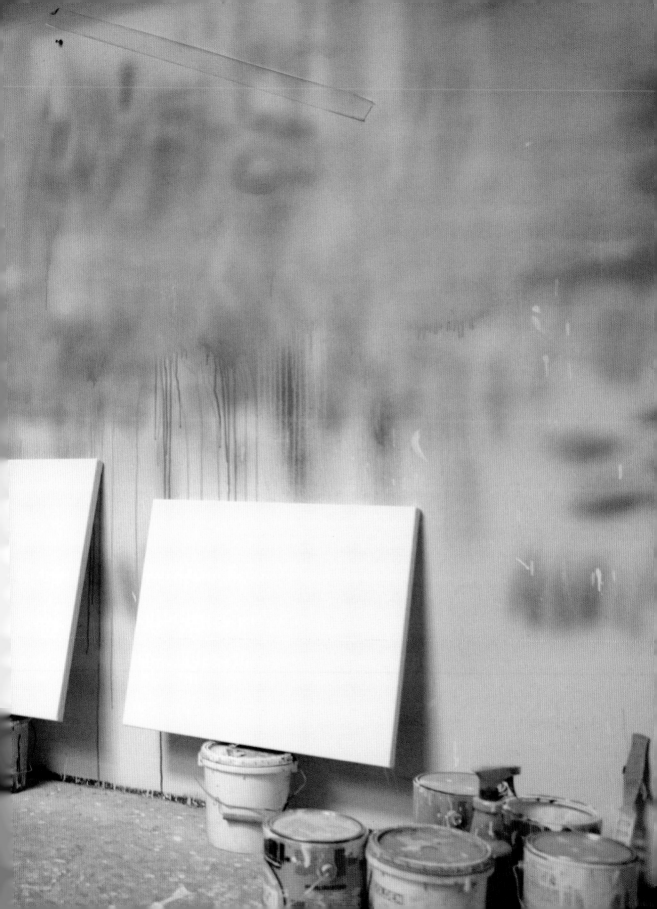

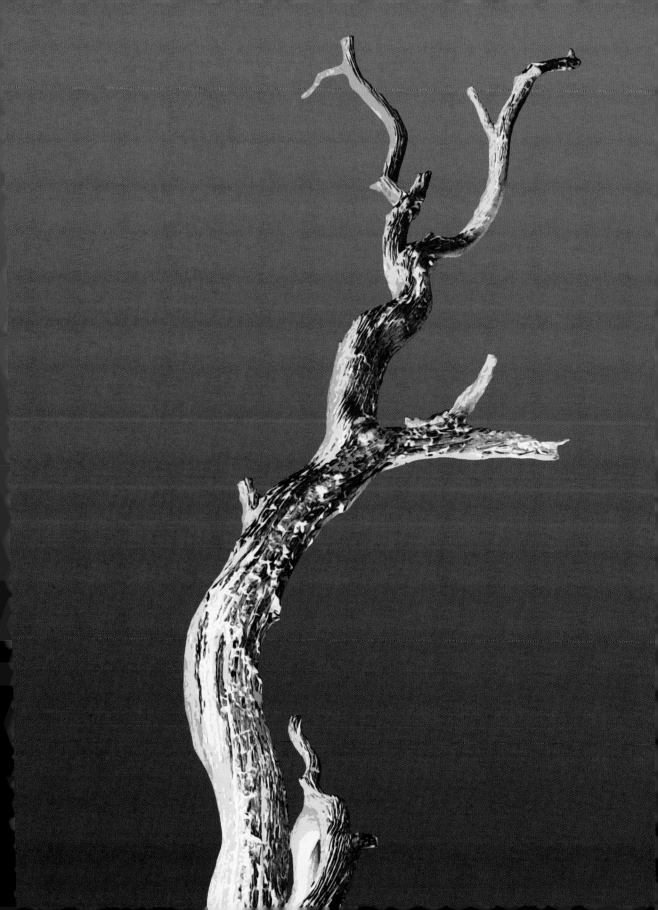

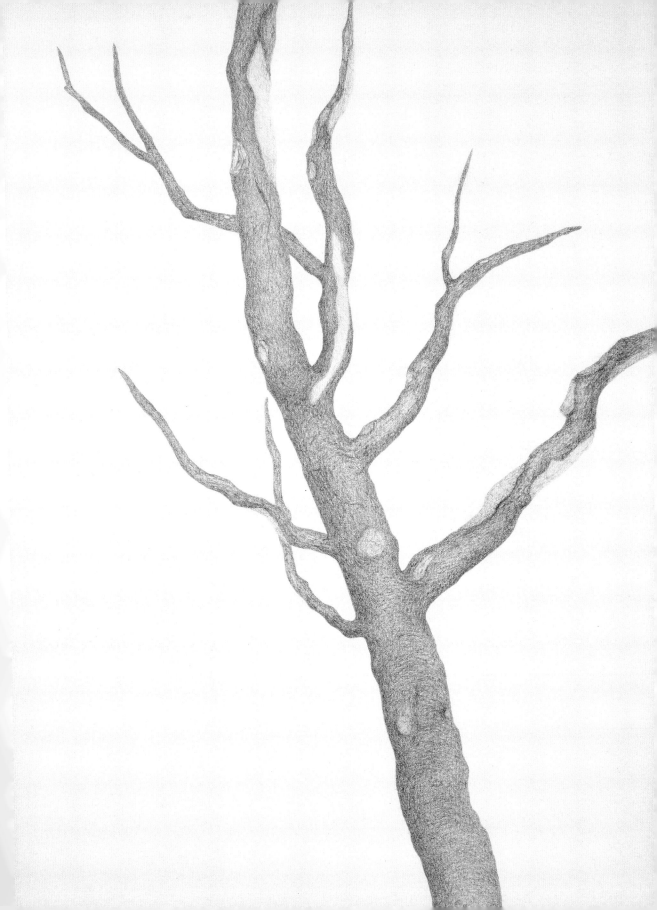

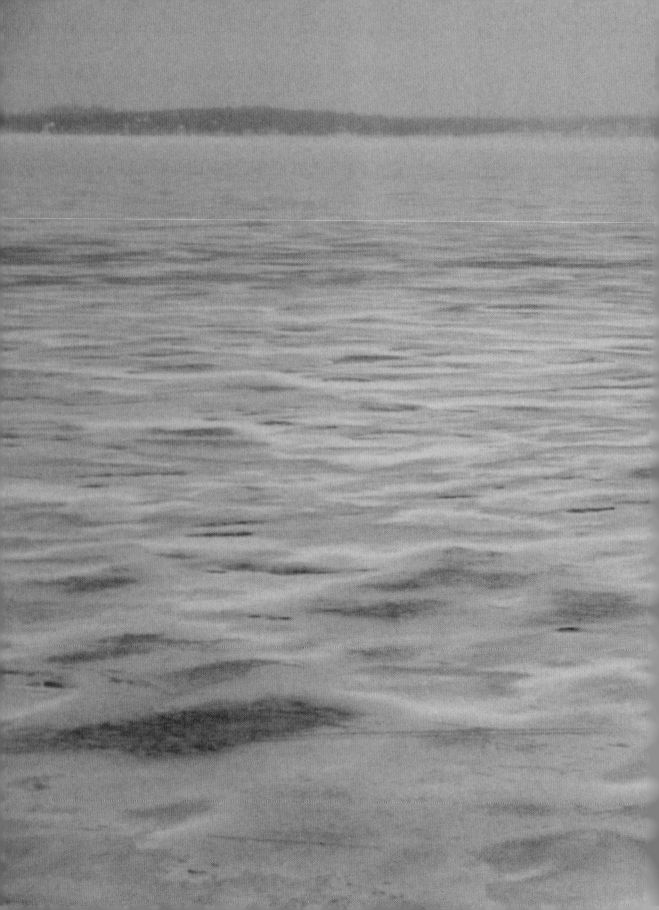

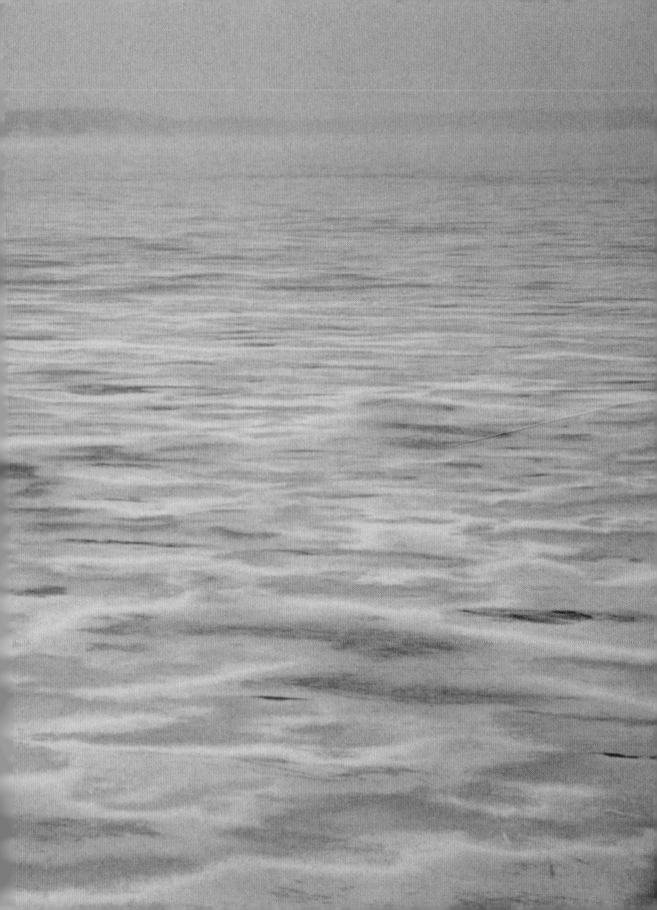

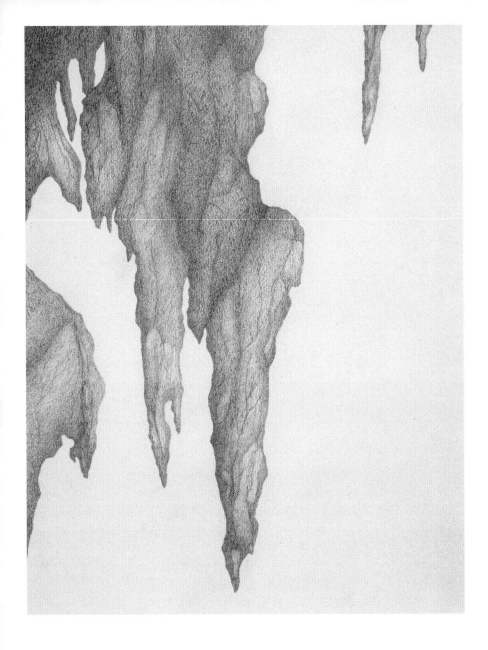

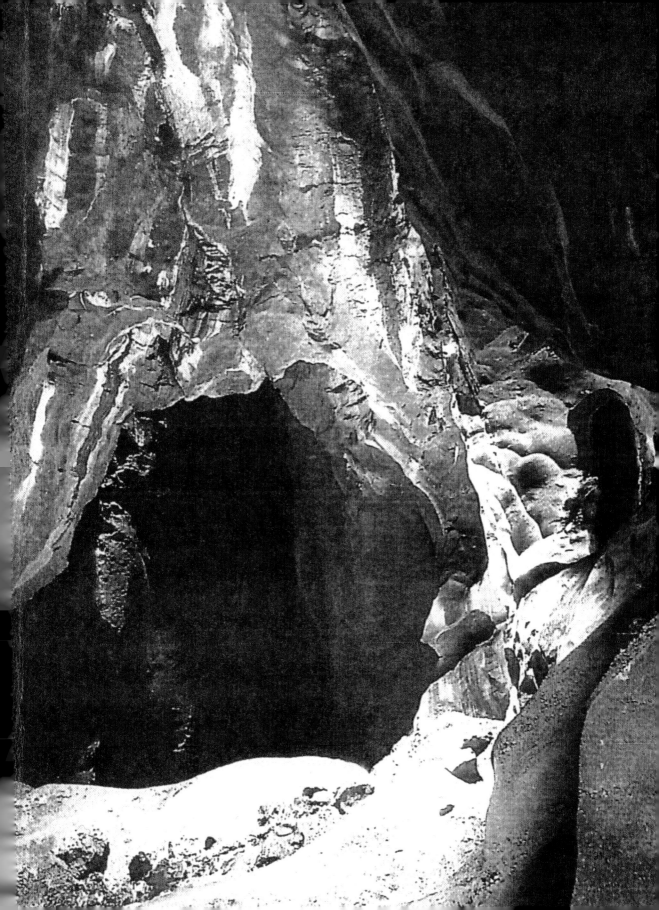

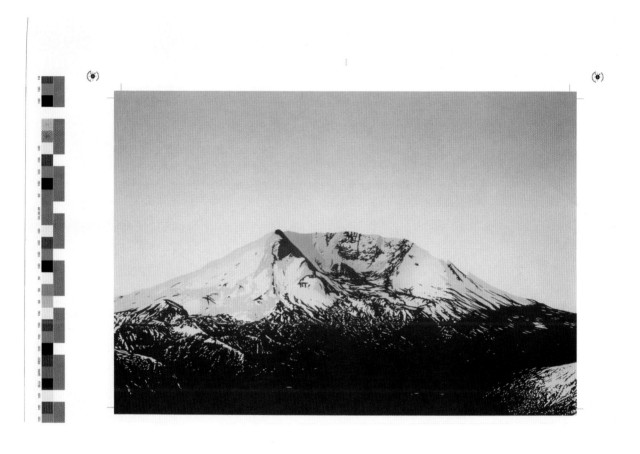

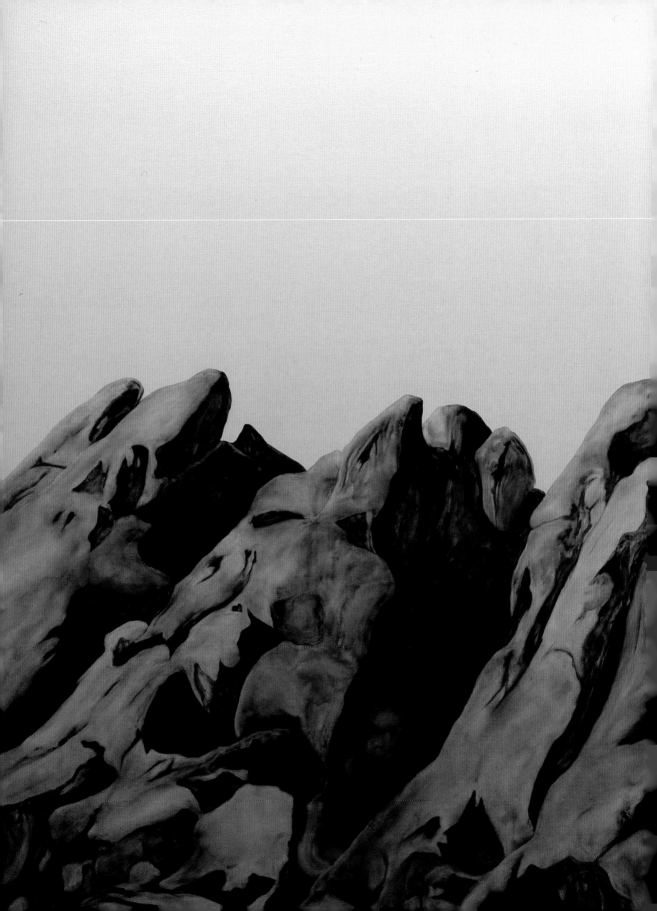

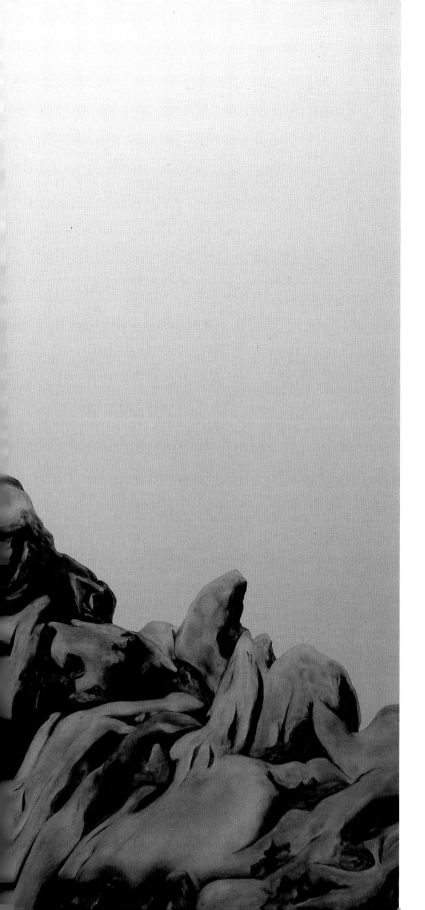

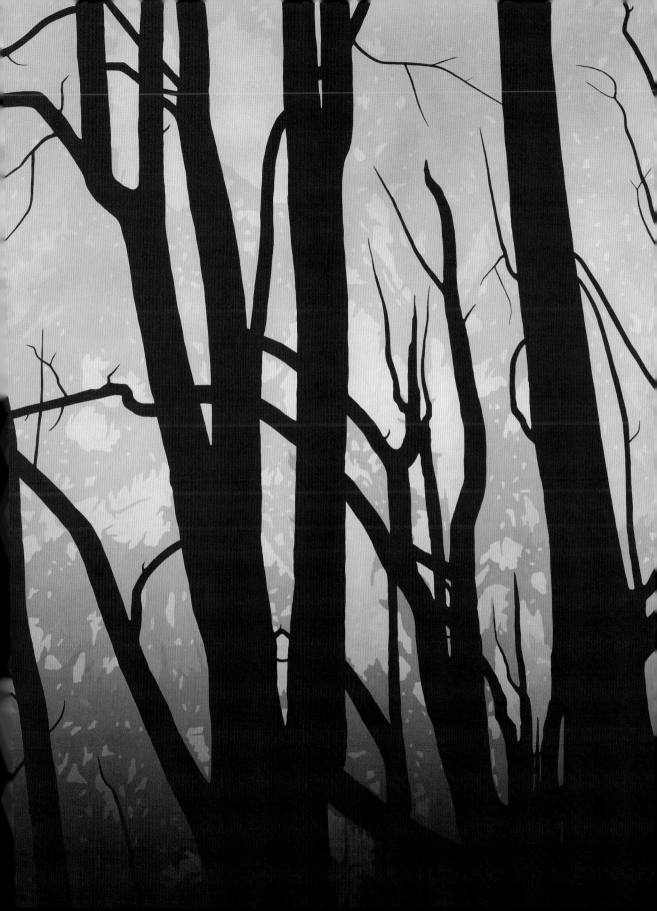

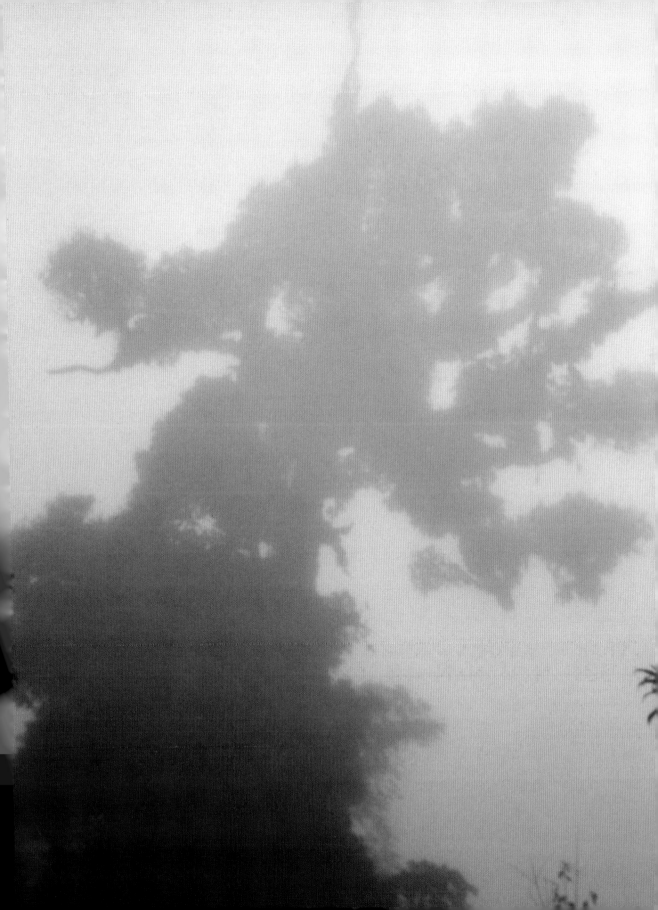

CAVES

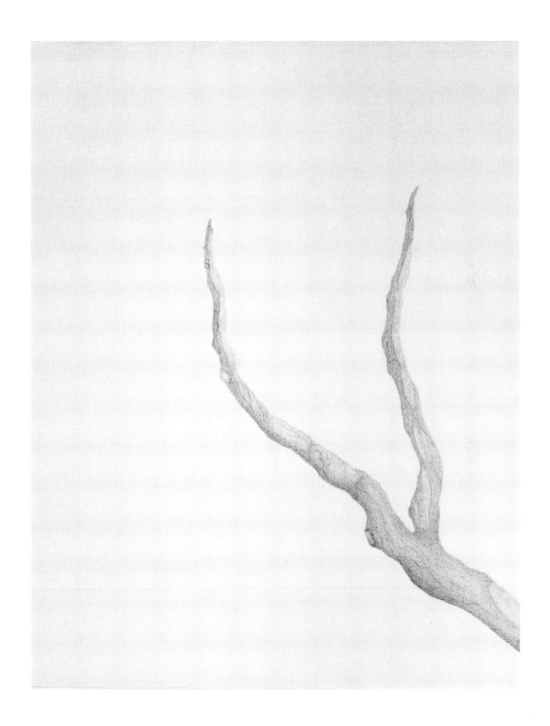

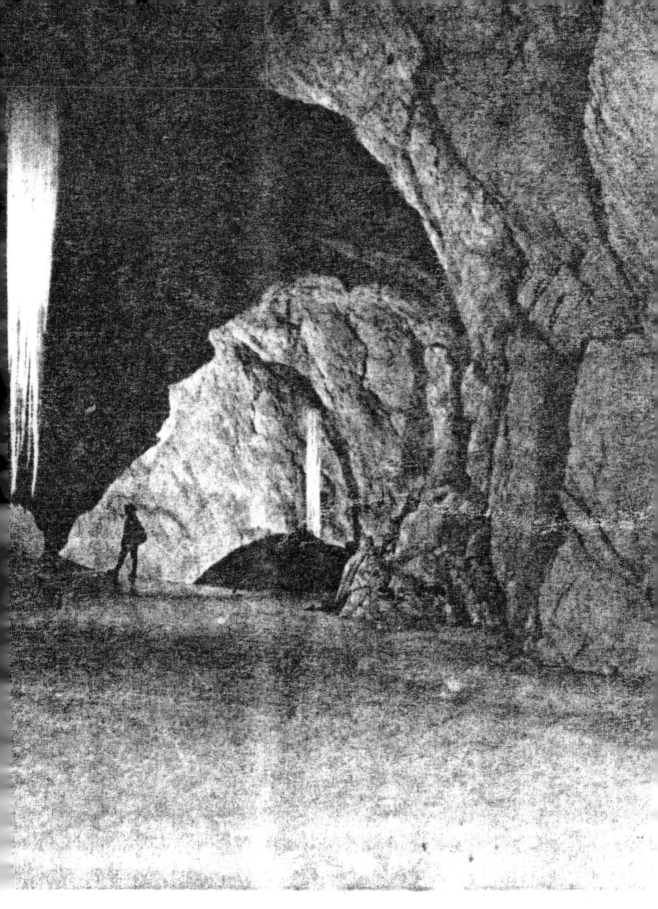

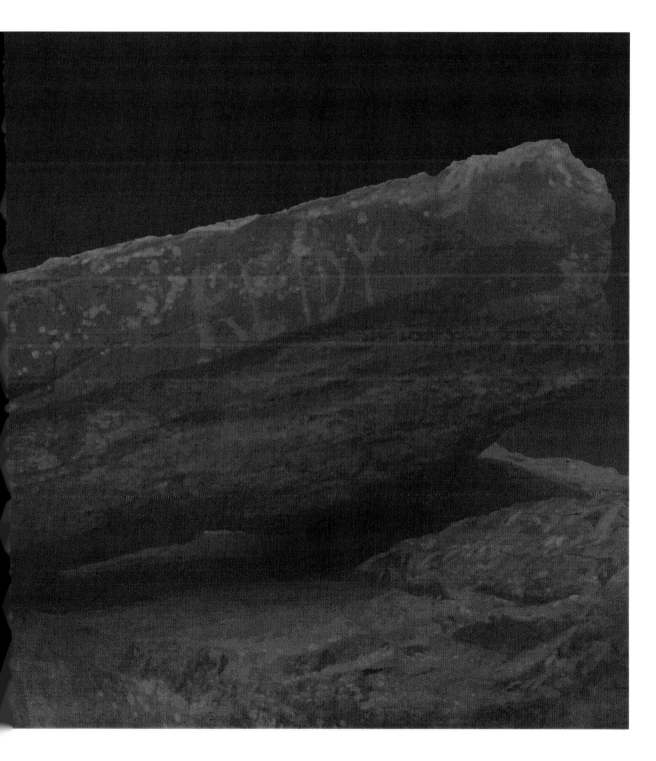

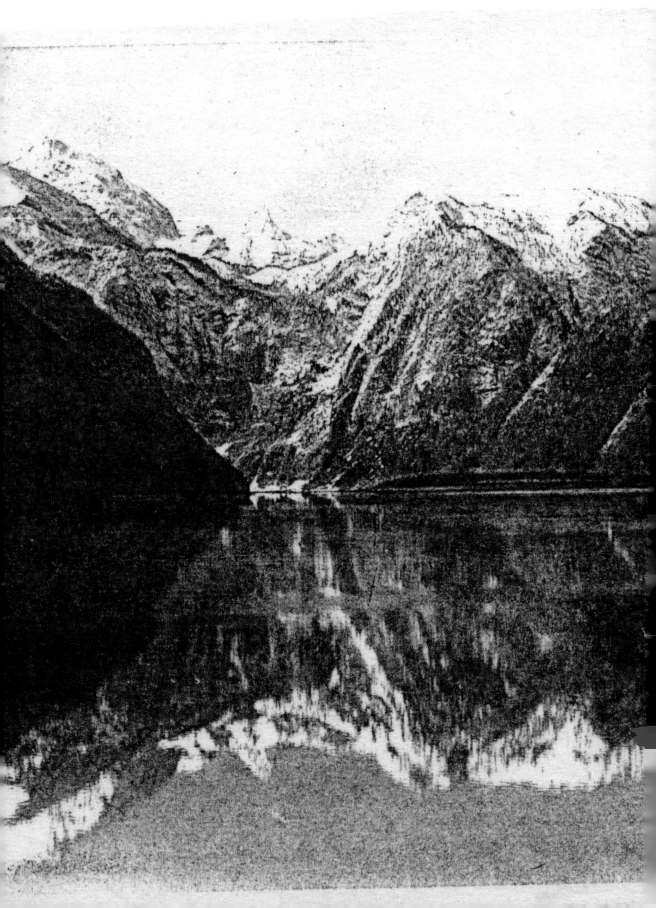

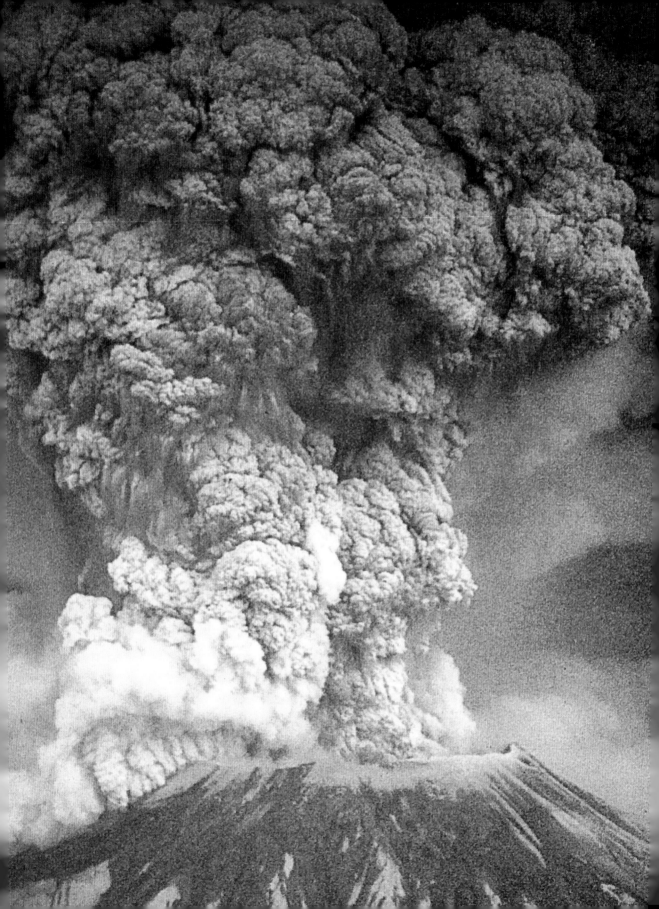

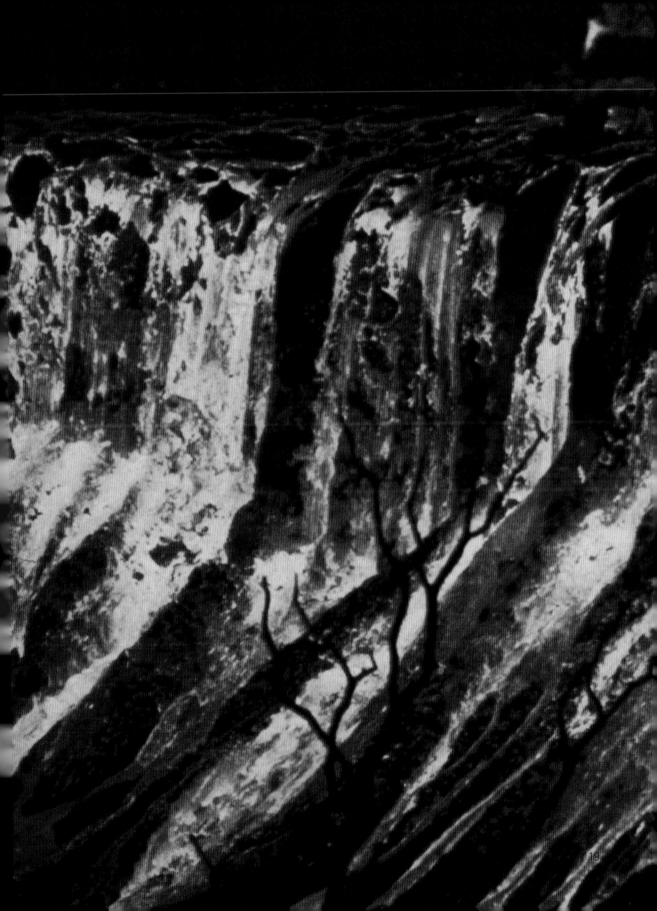

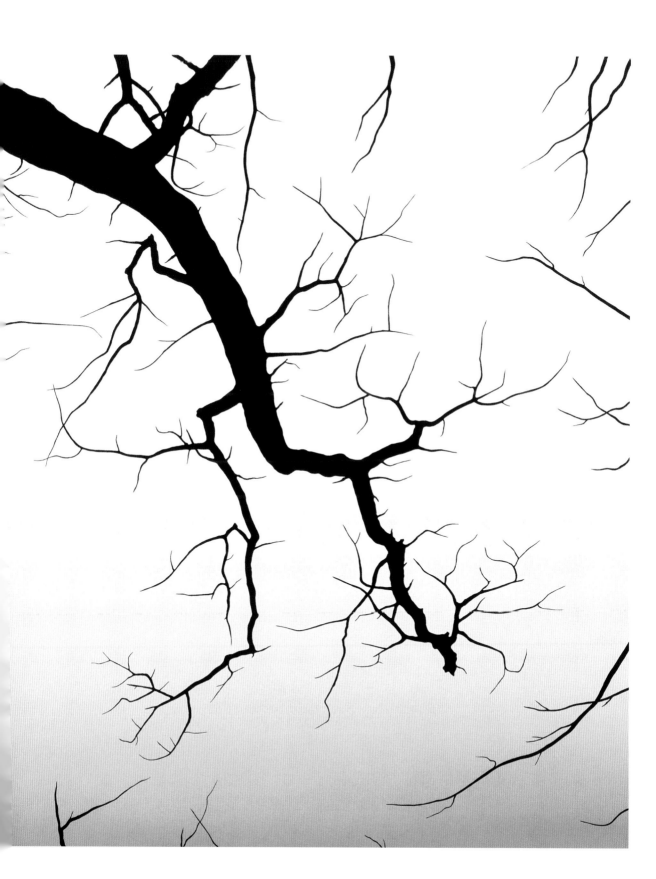

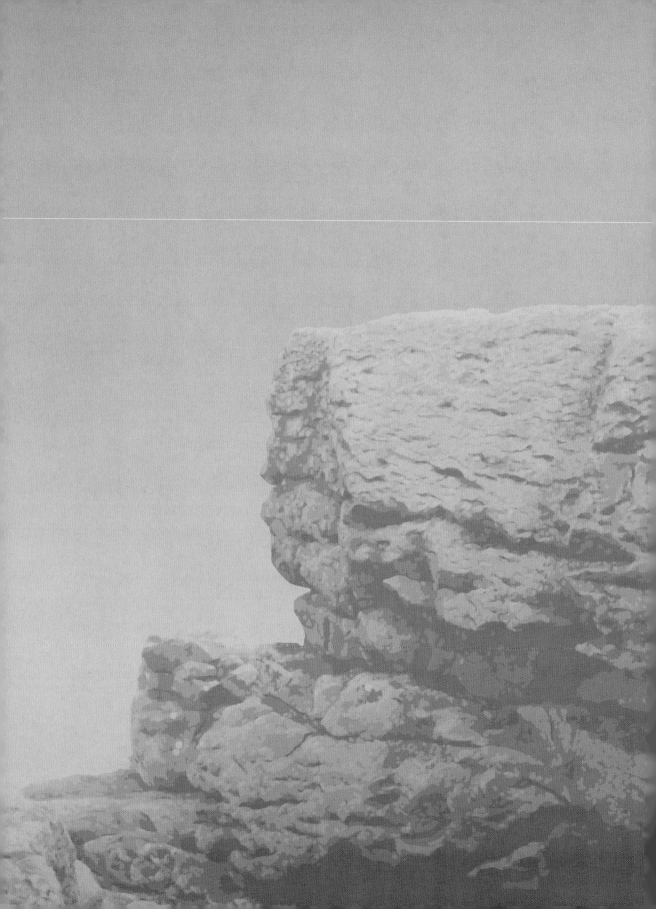

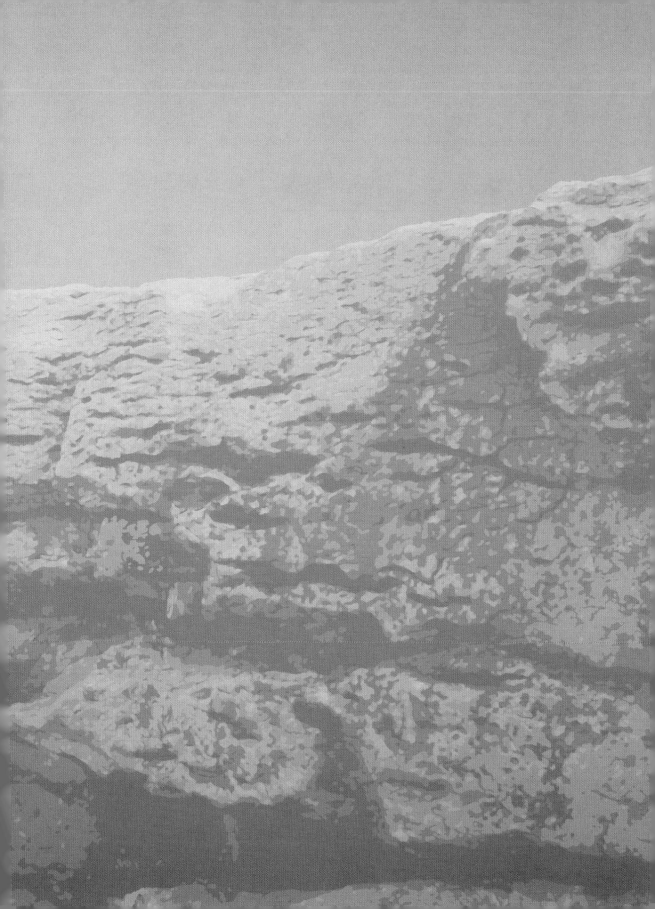

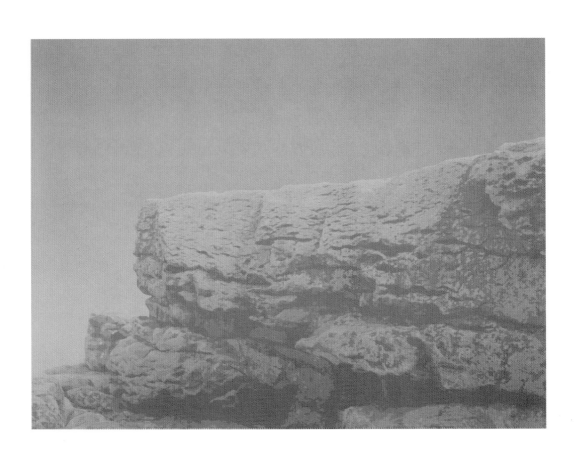

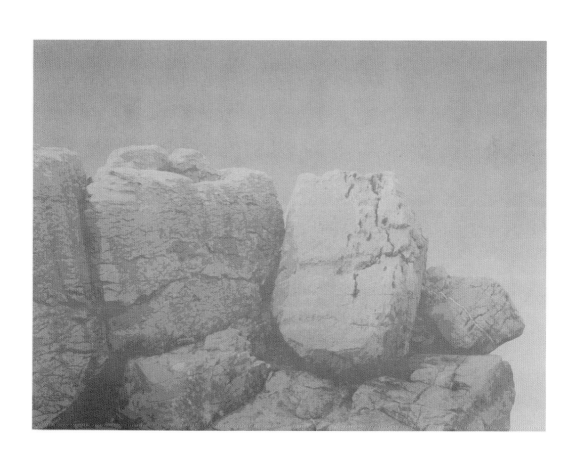

Of Man and Nature

By ALEXANDER DUMBADZE

1.

The approach to Falmouth, England was more than he had imagined. His initial thoughts perceived it as somewhat mundane: drifting into harbor, docking his sturdy, if not homely boat, coming ashore wobbly in the legs, checking into a small hotel, drawing a hot bath, and alerting, the following morning, the local Associated Press correspondent about his voyage. Instead, Robert Manry and his thirteen-and-a-half-foot boat, Tinkerbelle, arrived as national heroes in both England and the United States. Throngs of people gathered to welcome this humble, God-fearing man from the suburbs of Cleveland, who seventy-eight days earlier had set sail from Falmouth, Massachusetts in an attempt to satisfy a long standing desire to cross a massive body of water alone.

Manry seemed the least likely of individuals to attempt such a feat. In the summer of 1965 when he embarked on his North Atlantic odyssey, only his wife, his two children, his mother, and the Falmouth harbormaster knew what he was about to undertake. His colleagues at the Cleveland Plain Dealer, where he worked as a copy editor, were under the impression that he was sailing with a friend in a larger boat. Manry, who was raised in India, fought in World War II, and enjoyed a modest, middle class existence, kept this information secret so as to prevent his friends from thinking him balmy. His reserved and cautious nature (friends also described him as socially awkward) insured that he was meticulously prepared for his journey, outfitting his thirty-seven year old sloop with a cabin and other structural necessities to make her seaworthy. He chose his provisions carefully, and made sure that he had enough spare equipment. There was nothing rash in his decision making process. It was ploddingly methodical, as he believed that he had a moral obligation to take every precaution so that he would not shamefully endanger the lives of others who may need to rescue him.

The trip, which saw him essentially follow the westerly winds while sailing below the shipping lanes, was in many ways uneventful. He did not face immediate

distress, nor did he ever encounter significant physical problems. To the contrary, and much to his wife's happiness, he lost around forty pounds due to his exertion. Still he confronted on several occasions gale force conditions, and it was during these times that his particularly squat and wide beam boat tackled twenty-foot seas, and surfed down the crests of these massive forces of nature. Despite his small craft's uncanny ability to handle rough waters, she was nevertheless knocked down at least once, and Manry was tossed overboard six times. His lifeline kept him from being separated from his vessel, tying his fate with hers. Dangers such as these were perhaps the most manageable. The extremities of specific situations made him more attuned to his surroundings, his nautical acumen honed to the rollicking rhythms of the sea as he guided his sloop through the peaks and valleys of liquid mountain ranges. It was during the moments, however, when he was becalmed in the still Atlantic, the water flat as glass, the sea birds nowhere in sight, and other boats not to be found, that he faced utter loneliness. He did not posses a two-way radio, although his shortwave could pick up the BBC and Voice of America. His sheer isolation was emphasized by the fact that his life was contained within a small wooden frame—the only barrier between him and the endless blue waters that cascaded over the elusive horizon lines. On several occasions Manry hallucinated, a physiological response brought on by his psyche trying to come to terms with such absence, and an adverse reaction to the uppers he would periodically take to stay awake when rough weather demanded he remain on deck for hours at a time. His visions, sometimes ghastly in nature, subsided when he could finally sleep. But even this was difficult because if he was not worrying about being run down by an unsuspecting cargo ship, he was trying to fit himself comfortably into a cabin where he could only curl his legs. What might be perceived as hardships, Manry took as great joy. His infrequent bouts of depression, often brought on by solitude, were countered by the rising of the sun, stiff breezes that offered good sailing, and the endless variations of the sea, which he began to take note of with great care, filming and snapping pictures so that he would have a record of his adventure.

As the journey progressed, he reflected upon the magnitude of the event. He realized that this was not a normal endeavor, despite his firm conviction that Tinkerbelle was more than able to handle her own at sea. When he posed himself questions as to why he was making such a trip, he could not give a very satisfying,

or at the least, profound answer. This was something he simply wanted, but this brashness of heart brought on pangs of guilt as he wondered what right did he have to leave his family as he did, or whether it is morally responsible to abscond human contact for so long. He wrestled with these thoughts and decided, albeit with some difficulty, that he was right in his pursuit of this voyage, that the three months at sea would provide him with a lifetime of contentment and a renewed sense of vigor needed to confront the humdrumness of suburban, professional existence. And it was with this simple declaration that Manry offered a polite critique of the everyday and imbued his journey with a degree of edge, since a small of part of him resented the routine of work and the suffocation of social conventions. Yet Manry was anything but radical, and his political convictions were muted and firmly placed in the mainstream. His comportment was unsettlingly normal, and his decision to grow a mustache during his trip seemed an act of hedonism.

A little over a week into his voyage, Manry was startled by the appearance of a United States Naval submarine. It had pulled alongside Tinkerbelle while Manry was deep in sleep. Several members of the USS *Tench*'s crew yelled frantically to see if he was in distress. Manry awoke with a bolt, and quickly charged on deck and had a brief, if somewhat confused, conversation with the submarine's commander. Manry convinced the slightly taken aback officer that all was well and that he was in no need of assistance, since this was where he wanted to be. This journey was an expression of his will, and over the next seventy days he tested the strength of his agency against the omnipresent power of nature. He hoped, humbly and subservient to the will of God, to find some balance, however fleeting, with natural forces that at any moment could rise up and devour him in spite of his intentions.

2.

Manry's library was stocked with nautical literature. He knew the various stories of those who braved the ocean alone, and reveled in the knowledge that he was joining their esteemed company. None of these books, however, went with him to sea. Instead, he brought along *Gone with the Wind*, *The Spy Who Came in from the Cold*, and *Exercise Without Moving a Muscle*, but these tomes rarely left the cabin. He lacked a proper self-steering device, leaving him incapable of holding a book because one hand had to be on the tiller while the other trimmed the sails. As Manry

was crossing the Atlantic from West to East—eyes firmly cast forwards, hands put into action, and body in commune with the ever changing water—John Riding was on his way to Newport, Rhode Island—after stops in Spain and Bermuda—in his twelve-foot vessel. Never did these two kindred spirits cross paths. Destiny, it would seem, could not work out such an improbable meeting. Riding's trip went virtually unmentioned—a few blurbs here and there. It was a response almost to the contrary of Manry's, who became a victim of chance, an example of a specific action taking on greater meaning simply because of its timing.

Tinkerbelle's entry into Falmouth harbor landed her and Manry in the record books. He was the first to cross the Atlantic single-handedly and without stopping in such a small craft. This achievement, and the accolades that came along with it, were not the reasons behind the trip; the somewhat discordant metaphysical impulses that impelled his journey in the first place were muted by an anticlimactic conclusion. Manry reached the mouth of the harbor around six in the evening. He was still about two miles from shore, and the winds were dying down drastically. He was greeted by a large flotilla of spectator boats, which made it difficult to tack back and forth in search of elusive breezes. The harbormaster suggested that he tow Manry the rest of the way, as there were thousands of people—including the mayor, who had already pushed back his vacation plans—waiting anxiously for this intrepid sailor from the inland coast of Ohio. Manry eventually agreed, his sympathies for those in attendance outweighing any need to complete the voyage on his own accord. The lack of wind at the finish seems a cruel twist of fate. For weeks, Manry had encountered steady gusts, often sailing with mainsail reefed and his jibbed trimmed. Now as he approached the end, at the stage where he could almost say that he mastered the elements, nature stopped participating. She left Manry and Tinkerbelle adrift in her waters and at the mercy of those kind enough to see them to the docks.

This gentle reminder of nature's unlimited power, its ability to quash hubris instantly, occurred once again in 1968, when Hugo Vihlen—a native of southern Florida and a pilot for Delta Airlines—decided to sail, this time following the easterly winds, from Casablanca to Miami in a boat measuring just under six feet. For eighty-five days, this specially designed vessel called April Fool steadily moved

towards Vihlen's home. Vihlen, a former fighter pilot in the Korean War, would sleep in two-hour intervals with knees pressed to his chest as he lay on his back. He subsisted on very little, and found comfort in the soothing voices of the BBC. On the penultimate day of his voyage he was within a few miles of the Florida coast. His goal was within eyesight, yet despite all attempts he could not coax April Fool any further. His minute craft—an oversized message in a bottle—could not conquer the strong winds from the west nor the four knot gulf stream current, which carried this little ship ever further from the shore. He was subsequently picked up by the Coast Guard, who brought both Vihlen and his boat back to Florida and the small crowd gathered for his return. In some ways, the massive disappointment experienced by Vihlen was fair. He had no right sailing so far in a boat so seemingly ill-matched for the conditions. The tenuous balance between Vihlen and the Atlantic Ocean came suddenly to an end—a reminder of one's place in the world and recognition that elusiveness is one way nature exerts its dominion over the will of man.

3.

The days following Manry's landing in Falmouth were a whirlwind of activities. He had numerous media obligations, and traveled to London with his family, where he was feted with great fanfare. It is hard not to believe that this was all too much for him; that his prior experiences could in no way have prepared him for this sort of attention. It must have gone to his head as he thought, perhaps, that his ordinary life had been supplanted by something more glamorous, something beyond the dross of what he knew before he set sail. There is a telling picture that conveys this transformation. It was published in the New York Times and shows Manry returning home aboard the Queen Mary. Tinkerbelle had been given a place of honor on the massive ship's deck, and Manry sits once again in her, this time in a neatly tailored suit. He looks good in his new clothes. His slimmer frame makes him look youthful, and his mustache gives him an air of manliness and gravitas he previously lacked. He waves to the camera with a big smile. It seems heartfelt and jovial in a way Manry was supposed to be. He was known to laugh loudly when happy, and it would seem that this moment was no exception. Yet this photo, the celebrations, the refiguring of Robert Manry all seem far removed from the man who ever so quietly set sail from the Northeast Coast of the United States. Whatever

revelations Manry had at sea, whatever insights he gained about existence from observing the infinite variations of the ocean, they appear suddenly lost in the photo, in this succumbing to the powers of societal mores, to the demands of others—all of which began when he politely acquiesced to the harbormaster's offer to tow Tinkerbelle the final stretch.

Manry died in February 1971 of a massive heart attack. His beloved wife, Virginia, had died two years earlier in a car accident. His children, in the time since his return, had grown distant. Their classmates resented them, and the attention received by their father only encouraged others to bully them, especially the youngest, Douglas. Sometime between resettling into ordinary life in Cleveland, his squabbles with his children, and grieving the tragic loss of his wife, Manry, it seems, edited the 16mm film he shot during his trip. For years, this hour-long narrative was stored in Manry's brother's garage, and only of late has it become available. The film proceeds chronologically and even tries to represent—through the aide of illustrations—his hallucinations. Midway through this compendium of takes, there is a touching scene that shows Manry eating a plum pudding prepared by his wife. The cake was to celebrate passing the midway point of his journey. The shot is obviously quite close because of the limited space aboard Tinkerbelle. Manry sits inside the cabin, but the camera is on the deck. Most of the time his face is cropped by the frame of the image. This adds to the tenderness of the moment, as he earnestly prepares to eat what is undoubtedly a special treat. At once there is something childlike and heroic in his spreading of cream atop the pudding. He eats patiently and even fastidiously. It is here that Manry truly seems himself—for just a moment a balance was struck between his will and the mighty ocean everywhere around him.

Sources

Farnsworth, Clyde H., "English Cheer as Ohioan Ends Atlantic Crossing in 13 1/2 foot Boat," The New York Times (August 18, 1965).

Graham, J.A. Maxtone Graham, "An Airline-pilot-turned-navigator Describes Crossing the Atlantic in a 6-foot Boat," Sports Illustrated (May 3, 1971).

Long, Tania, "Conqueror of Sea Returns on Liner," The New York Times (September 1, 1965).

Manry, Robert, Tinkerbelle (New York: Dell, 1967).

Ramesh, Sarmishta, "Fathom This: Hugo Vihlen Broke the World Record," The Sun [Sunnyvale, CA] (October 27, 2004).

Robert Manry Archive, Special Collections at the Cleveland State University Library, http://www.clevelandmemory.org/manry/index.html.

"Sailing Feat 'A Bit of All Right,' British Agree," The New York Times (August 19, 1965).

"Sailing Newspaperman: Robert Neal Manry," The New York Times (August 17, 1965).

UPI, "Yachtsman Safe 3 Days from Goal," The New York Times (August 17, 1965).

UPI, "American in 6-Foot Boat Crosses the Atlantic in 84 Days," The New York Times (June 22, 1968).

Image Index

Cameron Martin: analogue
Published in 2009 by GHava{Press}, Brooklyn, NY
©2009 GHava{Press}
All paintings and drawings ©1999-2008 Cameron Martin.

Design: GH avisualagency
Artwork Photography: Ron Amstutz
Typography: Grotesque and Joanna
Printed by: Oceanic Graphic Printing
First edition - 1500 copies

Printed in China
ISBN: 978-0-9716702-3-5

Distributed by D.A.P / Distributed Art Publishers
155 Sixth Avenue, 2nd Floor, New York, NY 10013
Tel: 212.627.1999 Fax: 212.627.9484